A Pony in the Picture

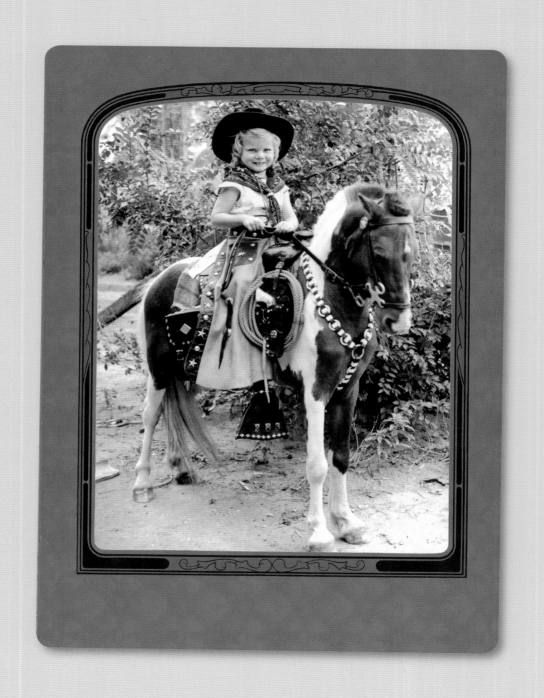

A Pony in the Picture

VINTAGE PORTRAITS of CHILDREN and PONIES

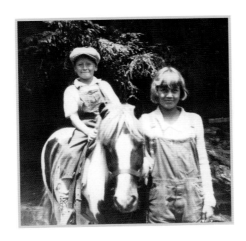

Victoria Randall

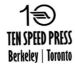

TEN SPEED PRESS
Berkeley | Toronto

🔟

Ten Speed Press
PO Box 7123
Berkeley CA 94707
www.tenspeed.com

Distributed in Australia by Simon and Schuster Australia, in Canada by Ten Speed Press Canada, in New Zealand by Southern Publishers Group, in South Africa by Real Books, and in the United Kingdom and Europe by Publishers Group UK.

The Pony Man, words and music by Gordon Lightfoot Copyright © 1968, 1970 by Early Morning Music. Exclusive reprint rights administered by Alfred Publishing Co., Inc. All rights reserved. Used by permission of Alfred Publishing Co., Inc.

Cover and text design by Chloe Rawlins

Cover photo circa 1915
Photo page ii circa 1950
Photo page iii circa 1935
Photo page v circa 1905
Back cover photo circa 1950

Library of Congress Cataloging-in-Publication Data

Randall, Victoria, 1955-
 A pony in the picture : vintage portraits of children and ponies / Victoria Randall.
 p. cm.
 Includes bibliographical references and index.
 ISBN 1-58008-881-3 (978-1-58008-881-7 : alk. paper)
 1. Photography of children. 2. Photography of horses. I. Title.
 TR681.C5R36 2007
 779'.2--dc22

 2007012548

ISBN 13: 978-1-58008-881-7
ISBN 10: 1-58008-881-3

First printing, 2007

Printed in China

1 2 3 4 5 6 7 8 9 10 — 11 10 09 08 07

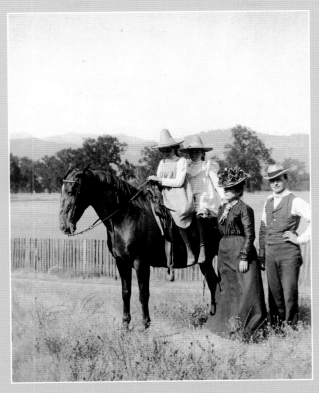

For my father, who passed on to me a love for all horses, large and small,
my mother, who spent so many hours of her life patiently indulging that love,
my sister, who started this collection,
and my David, who gave me the idea to make it into a book and
without whom I wouldn't have my dream—a horse of my own.

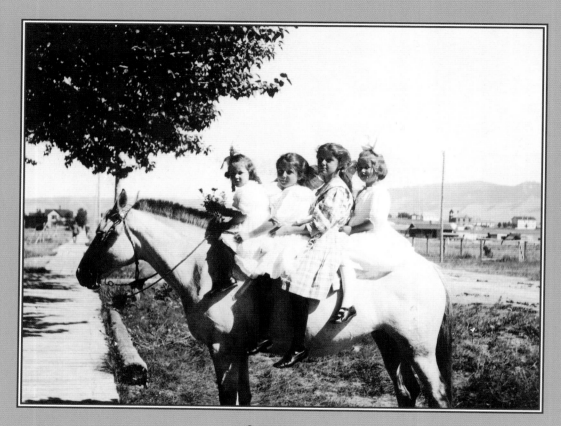

CIRCA 1910

Acknowledgments

It really does take a village, or at least a stable, to create a book and I owe everything to the tireless team who worked so hard to help me fulfill my vision. I am so grateful to my publishers, Phil Wood and Lorena Jones, who believed in me and this project right from the start; to designer Chloe Rawlins for her special combination of good taste and exceptional skill; and to Hal Hershey and Serena Sigona for their meticulous attention to production details. Donna Long, Sarah Handler, Debra Matsumoto, Robin Gainey-Sanford, Dale Siperstein and Judy Siperstein, Susan Weinstein and Jourdan Meltzer, Jaimie Anderson, Steven Lurie, Roberta Lurie, and Lori Seidman loaned some very special images for which I shall always be grateful. And, finally, thanks to my incomparable editor, Veronica Randall, who also happens to be my beloved sister, my other, better half. Her name should really be on the title page alongside mine, because without her, this would still be just a collection of lovely old photographs; it wouldn't be a book at all.

CIRCA 1920

About the Photographs

IN 1839, FRENCHMAN LOUIS DAGUERRE was the first to "fix" an image to a sheet of silver-coated copper, thus creating the first permanent photographic plate. Others had previously managed to capture images temporarily, but no one had developed a way to chemically secure a picture onto a permanent surface. Thus, within hours of the original making of the picture, it would fade slowly away often leaving only the faintest ghost of the image before it completely disappeared. The new daguerreotype was a positive image that, although it could not be reproduced, nonetheless caused a worldwide sensation. For the first time, an exact likeness of a person, place, or any creature or object could be captured and preserved forever in a process that took a fraction of the time needed for a painted or sculpted likeness to be made.

Within twelve years, the daguerreotype was replaced by the improved technologies of the tintype, ambrotype, calotype, cyanotype, and the collodian or wet-plate process. Then, in 1889, American George Eastman invented the first film camera, revolutionizing the newly popular activity of photography in two significant ways: first, the compact, self-contained roll of flexible, gelatin-coated film allowed the camera itself to be greatly reduced in size and weight, and therefore, portable; and second, a photograph made on film created a negative image that allowed it to be reproduced on paper many times over.

The immediate success of film cameras led to the development of inexpensive printing methods. Soon it became possible to replicate a favorite image into postcards, cabinet cards, and calling cards. At a time before the telephone was commonplace, person-to-person

communication happened mainly by letter through the mail. The illustrated greeting card had gained widespread popularity following the Civil War. The more personalized post-card, imprinted with the photographic portrait of a family member or loved one, soon became a bona fide fad. The keepsake photograph made portraiture, once only available to the wealthy, possible on a mass scale.

In a fascinating historical parallel, the progress of modern photography coincided with a momentous cultural shift within the United States. Throughout the late 1880s and 1890s, American families were on the move across a young nation in search of greater prosperity. The Industrial Revolution was pulling first, second, and third-generation Americans from the farms they had grown up on to the crowded urban centers that promised high-paying factory jobs. At the same time, waves of immigrants, principally from Europe, arrived on America's shores, flooding the great eastern cities. As railroads spun out like giant spider-webs across the country and city trolley systems allowed the new workforce to push urban boundaries ever outward, the first suburban enclaves were born.

As the twentieth century dawned, many of these new city and suburb dwelling Americans found themselves fondly recalling the pastoral life they had left behind; a time when they lived in close proximity to their animals; a time when they relied on—and loved—their horses. For some, it would be the first time they felt a sense of nostalgia for the past. Perhaps because of this collective memory, parents sought out more romantic settings for portraits of their children—a way to capture a remembrance of things past, if you will. And what better way to coax a smile from a reluctant subject than a gentle nudge from the velvety muzzle of an equine friend?

Until the 1890s, portrait photography was still a relatively cumbersome and expen-sive proposition. The large-view cameras that produced daguerreotypes, tintypes, and ambrotypes were not easily transportable. Having a portrait made involved going to a professional studio and standing or sitting alone or in a stiffly posed group. But the new film cameras were smaller and lighter, which enabled a photographer to take his services

directly to his customers. The itinerant photographer became, like the traveling salesman, a fixture across the country.

In addition to his camera and tripod, a photographer was often accompanied by a small pony decked out in a fancy saddle and bridle. A straw suitcase full of cowboy costumes, including Stetson-style hats, wooly chaps, and toy guns, completed the tools of his trade. Youngsters were eager to dress up like little Davy Crocketts, Daniel Boones, Buffalo Bills, and Annie Oakleys and climb aboard shaggy, docile ponies. In fact, Western-themed outfits and tack would remain staples over the next sixty years, thanks to the enduring popularity of the movie Western from the silent two-reelers of the 1920s to the sound-era cowboy serials of the 1930s. By the 1950s, television had taken over and revived human and horse stars like the Lone Ranger and Silver, Hopalong Cassidy and Topper, Roy Rogers and Trigger, Dale Evans and Buttercup, Flika, Fury, and "National" Velvet Brown and her redoubtable horse Pie.

As recently as the 1960s, photographers with ponies still roamed American suburbs. The outfits had changed a little—tee-shirts and sneakers instead of stiff-collared shirts and high-button shoes—but the ponies looked the same and so did the smiling kids. Today, ponies have all but disappeared from beaches and boardwalks;

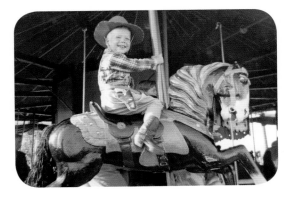

most theme and amusement parks have gone strictly high tech. Even the merry-go-rounds and carousels that once dotted the landscape have all but vanished. Pony rides are only common at state and county fairs and private backyard birthday parties nowadays.

Yet ponies still conjure magic for young children, and, interestingly, there are more horses and ponies in America today than there were at the turn of the nineteenth century

when they were still a primary mode of transportation, drayage, and farm labor. More than 300,000 kids are involved in 4-H club activities and pony clubs, and the success of the growing equine therapy movement is a testament to the special relationship between children and horses. Riding a pony makes a small child feel tall, a timid child brave, and a disabled child independent.

This book is filled with images of children and ponies and even a few horses, covering nearly eight decades. Some of the photographs retain detailed printed or handwritten descriptions, complete with names, dates, and locations. Most were taken in the United States, however there are a number of examples from Canada, Great Britain, Belgium, Germany, Argentina, and Burma. But many of them are a mystery, providing few clues as to exactly when or where they were taken, or by whom. Yet each image captures another time and place, when it seemed that all it took to attain a moment of perfect happiness was a shaggy Shetland pony and a borrowed cowboy hat.

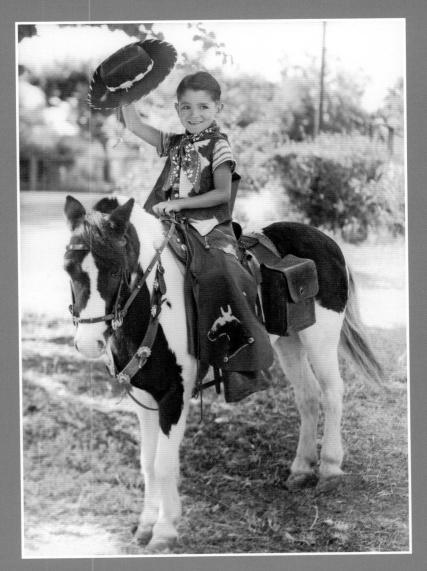

CIRCA 1950

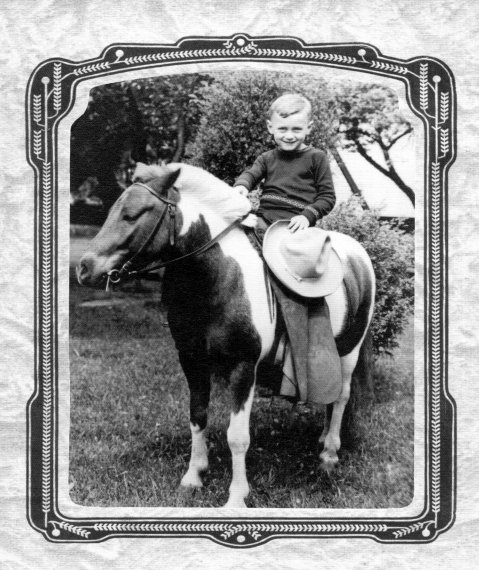

Circa 1930

THE PONY MAN

When it's midnight in the meadow and cats are in the shed,
And the river tells a story at the window by my bed,
If you listen very closely, be as quiet as you can,
In the yard you'll hear him,
It is the pony man.

We're all there to greet him when he tumbles into town,
He leads a string of ponies, some are white and
 some are brown,
And they never seem to kick or bite, they only want to play,
And they live on candy apples instead of oats and hay.

And when we're all assembled, he gives a soft command,
And we climb aboard our ponies as in a row we stand,
Then down the road we gallop and across the fields we fly,
And soon we all go sailing off into the midnight sky

—Gordon Lightfoot

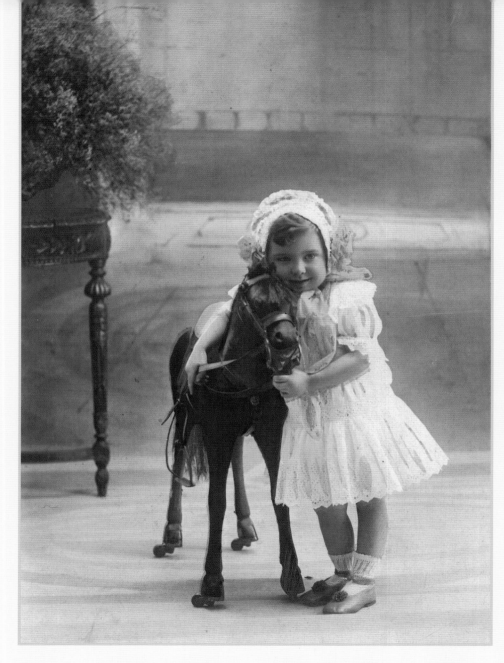

Stebbing Photographic Studio, Hasfelt, Belgium, 1908

Toy horses were favored among the many props used by American, British, European, and even Asian photographers to hold the attention of young children during the long exposure times needed to make a copper-plate or glass-plate studio portrait.

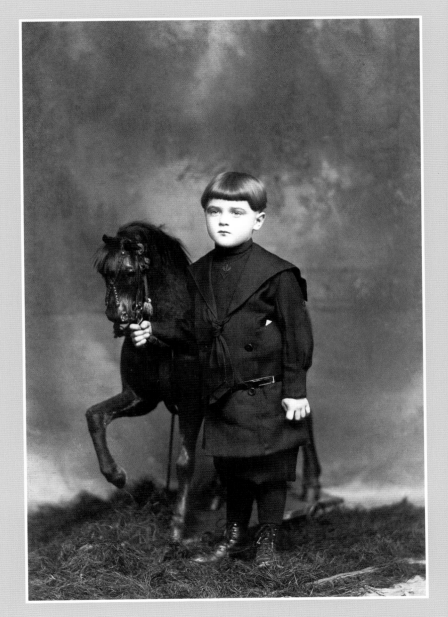

CIRCA 1900

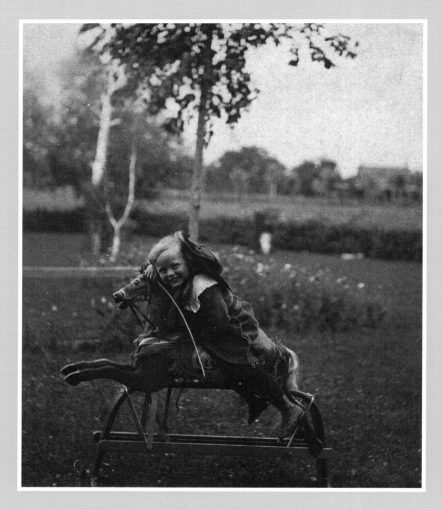

CIRCA 1910

In 1842, Sir John Herschel invented cyanotype printmaking. For this method, a sheet of paper was brushed with two light-sensitive iron salt solutions and allowed to dry in the dark. A negative image was placed over the paper, which was exposed to direct sunlight for about fifteen minutes, then washed with water, leaving an oxidized positive image on the paper in a vivid cyan blue color.

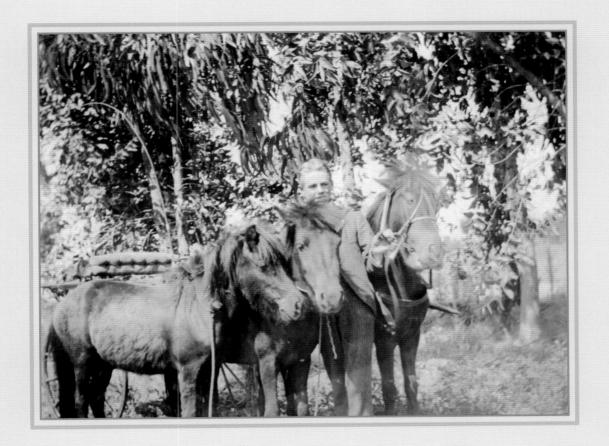

CIRCA 1885

The albumen print was developed in 1850 and remained the most common type of photographic print for nearly forty years. It was made by coating a sheet of paper with egg white and salt, then coating with silver nitrate. The salt and silver nitrate combined to form a light-sensitive layer that, when placed in contact with a negative image and exposed to sunlight, produced a permanent print.

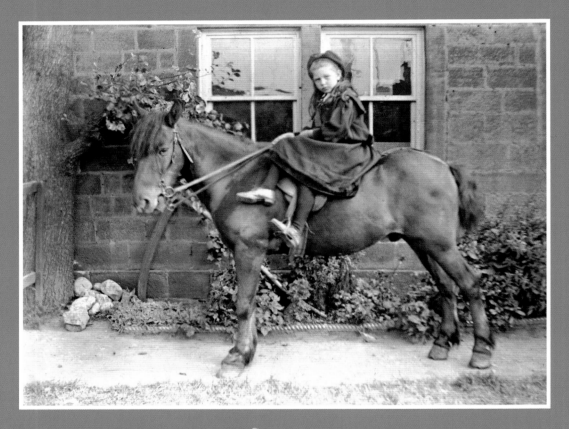

CIRCA 1880

Developed in the 1870s, the gelatin silver print had all but replaced the albumen print by the 1890s. Made by coating a sheet of paper with light-sensitive salts suspended in gelatin, the process produced a positive print that was more stable than any other printing method, and remains the standard today. The young equestrienne on her patient English Cobb is an unusual early example.

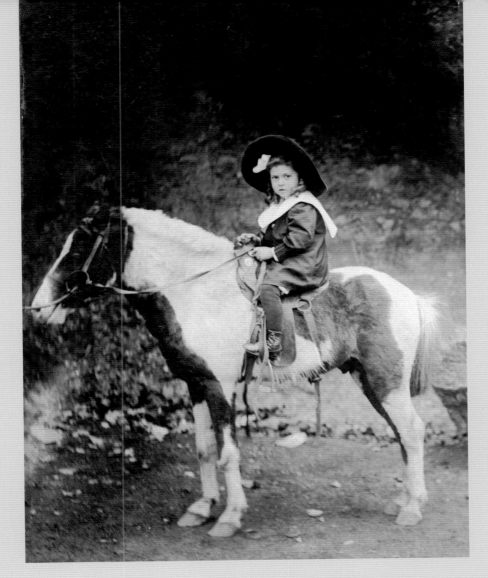

Francis H. Wyeth, son of Max Wyeth, age 4 years, March 1904

Photographed by McLeod, Happy Hollow, Hot Springs, Arkansas. On the reverse side of this print, the colorful Mr. McLeod exhorted his clients to: "Come see the animals, ride the donkeys and ponies, and get your photograph taken!" At first glance, the long ringlets on this young rider belie that fact he is a young man.

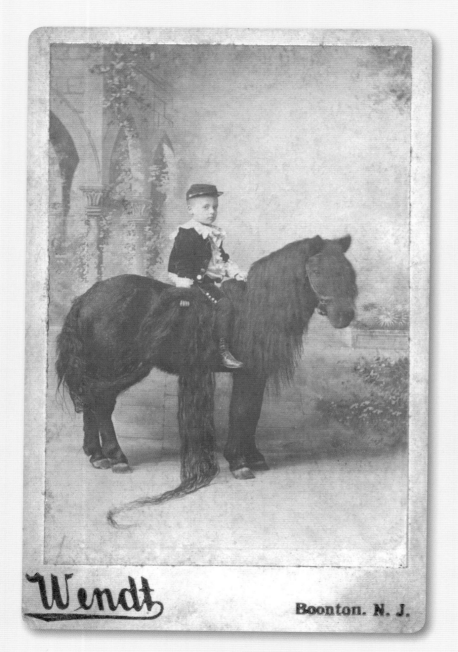

Wendt

Boonton. N. J.

By the 1880s professional studios were producing what came to be known as the cabinet card, a photograph glued to a cardboard mount that could be stood up in a display cabinet or on a mantle. Many were imprinted with the name and location of the studio, and some advertised that they provided donkeys and ponies especially for young children to pose with. The Wendt Studio in Boonton, New Jersey, provided a pony with an exceptionally long tail, so long that it drapes over the young man's right arm and cascades to the floor!

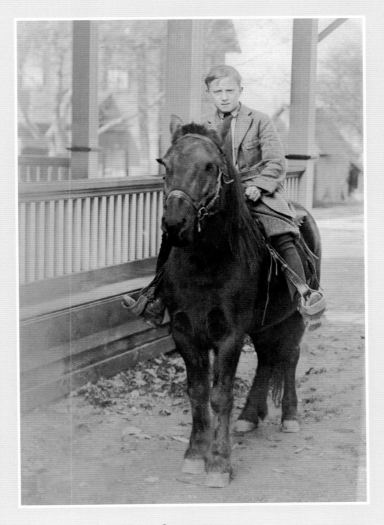

CIRCA 1914

The first, and still the best, best-selling novel of all time with an animal hero is *Black Beauty—The Autobiography of a Horse* by Anna Sewell. The first of countless editions was published in England in 1875, five months after the death of the author who would never know how much heartache and joy her beloved characters have given to millions of readers the world over.

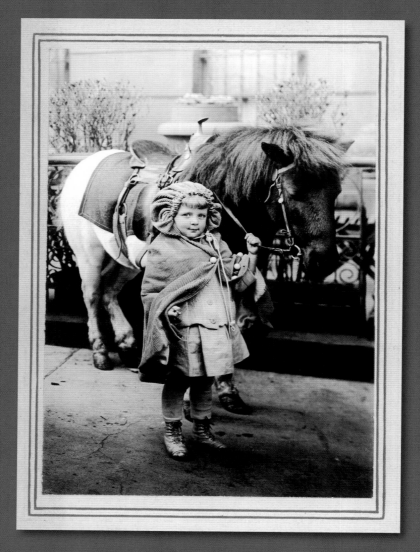

With the development of the film camera, photography became portable which meant that photographers were no longer tied to a studio but could ply their trade anywhere. Many of them literally took to the city and suburban streets in search of new clients.

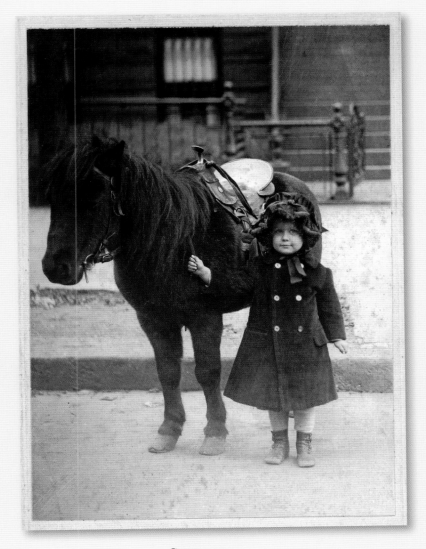

CIRCA 1918

Small size and a gentle disposition made the Shetland pony ideal for posing patiently with young children. This ancient and hardy pony from the Shetland Islands off of Scotland's rugged north coast was the most common breed used for this purpose.

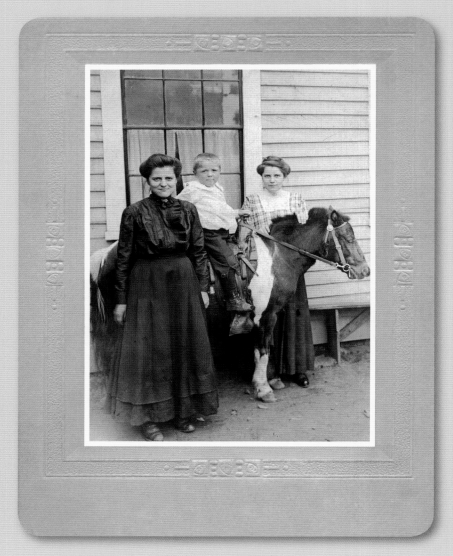

CIRCA 1910

An entire family took advantage of a traveling photographer and his pony passing through town for this pair of portraits.

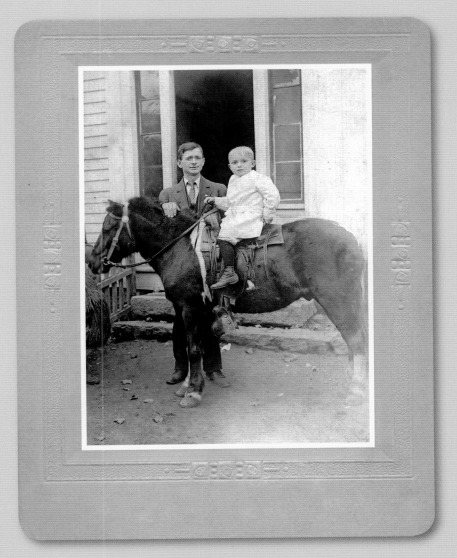

CIRCA 1910

Jennette's father and brother

Jennette is likely the young lady standing *(opposite)* with her hands on the pony's neck.

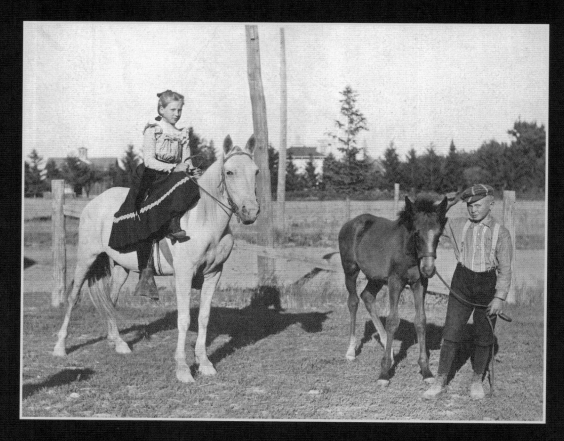

Circa 1890

Brother and sister showing off their riding mare and her foal

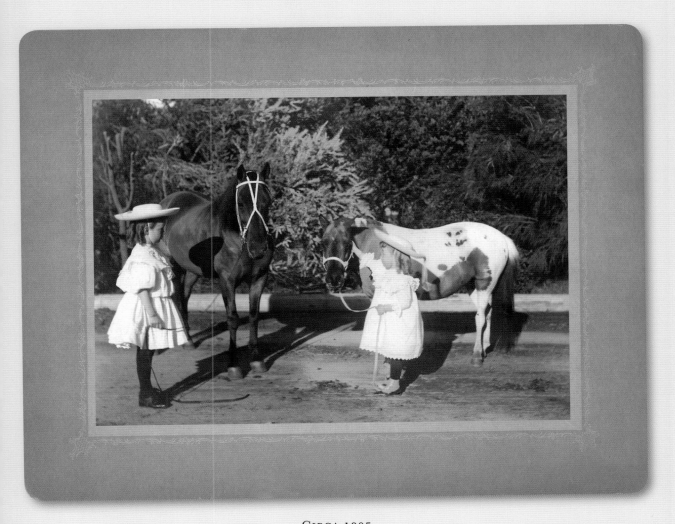

CIRCA 1905

Sisters with their ponies, photographed by G.E. Blanchard

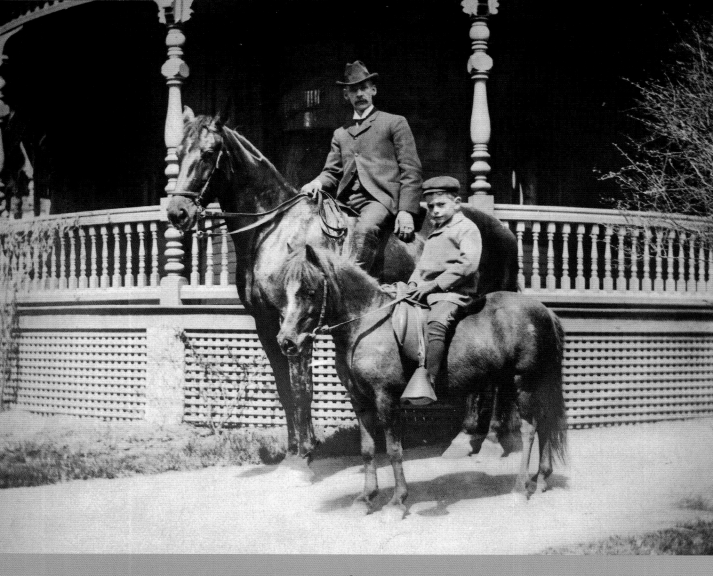

CIRCA 1904

Well-to-do families that kept horses also often kept ponies for their young children. Ponies are distinct from horses not only in size, but, most significantly, in their proportions. Ponies tend to be deeper through the body in relation to their height; in other words they are longer than they are tall, which is the opposite of most horses.

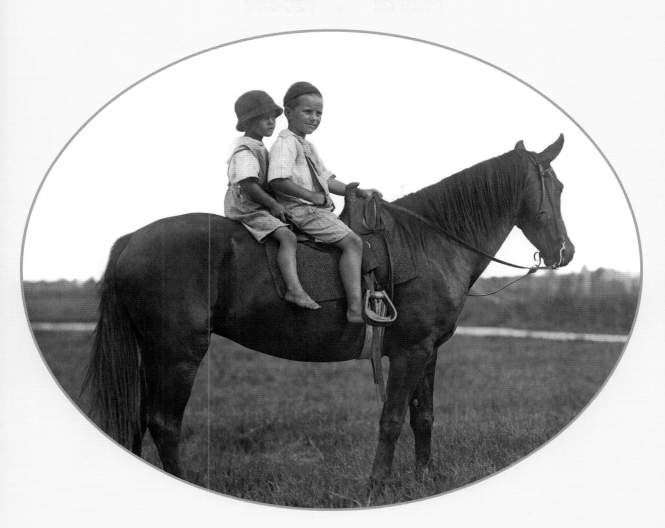

CIRCA 1920

**Marcus Milani Jr., age 8 years, in the saddle on his cow pony Annie,
and Paul Dawson, son of the farm manager, riding behind**

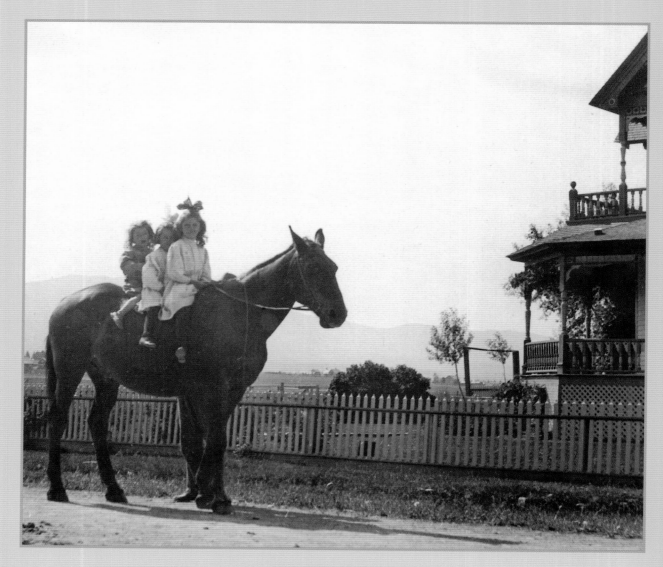

CIRCA 1908

(Above and opposite) These very small children seem quite comfortable posing astride very large horses.

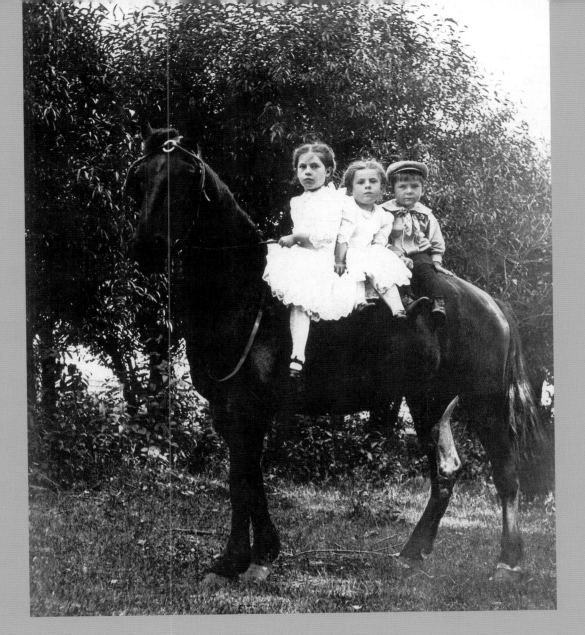

CIRCA 1905

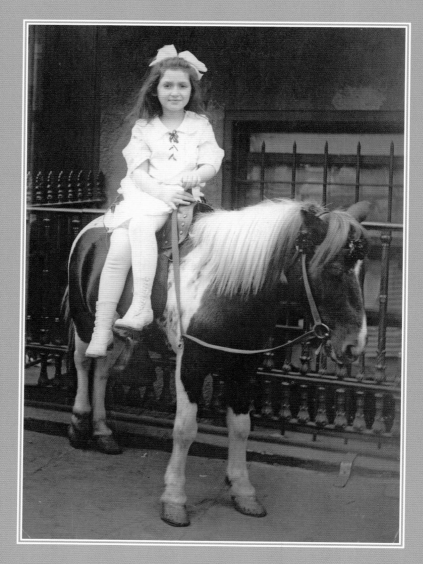

CIRCA 1905

Nothing is known for sure about this confident beauty, but perhaps she dreamt of riding a pony of her own.

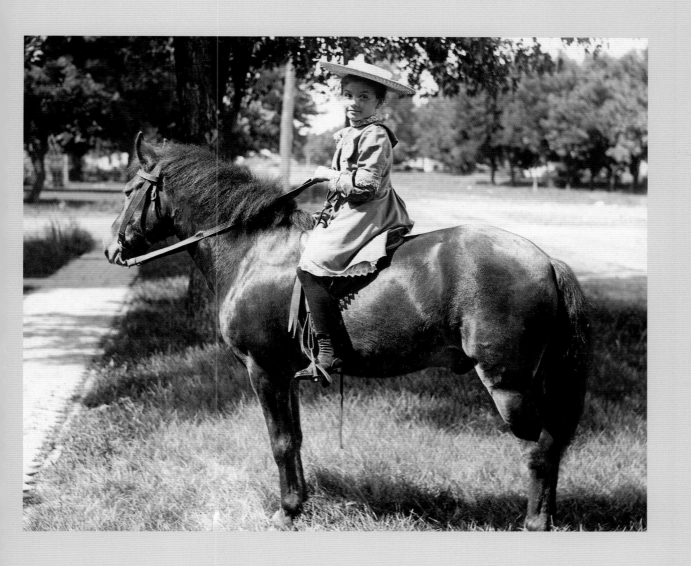

Taken June 1904, Vearle on her pony Dandy

Photographed by Elarton's Studio, Aurora, Nebraska

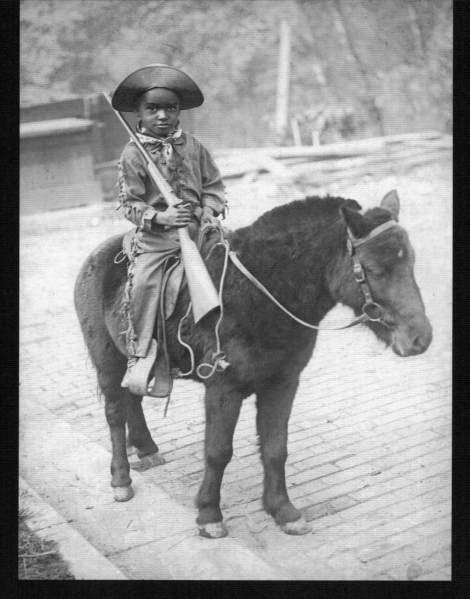

CIRCA 1915

This young fellow wears an impressively detailed "Indian scout" outfit, with fringed buckskin trousers and shirt, a neckerchief, hat, and a very real-looking rifle. Posed keepsake photographs of African-American children are quite rare.

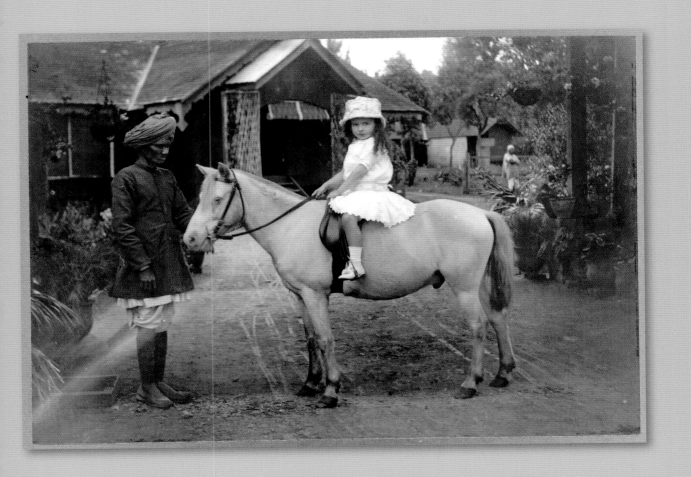

With Winnie's Love

Winnie Young, photographed by Mackay in Maymyo, Burma, 1915. Although her hat, dress, and shoes are hardly riding attire, it is likely that this is Winnie's pony, and not a borrowed mount, as the diminutive saddle fits her perfectly.

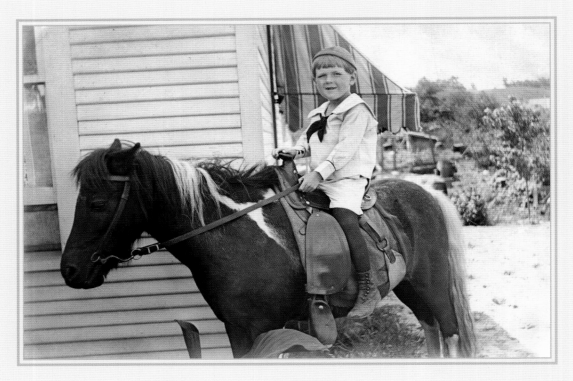

CIRCA 1910

It is commonly thought that ponies were first domesticated in Eurasia between five and six thousand years ago, but their origins stretch back to the end of the last Ice Age, some ten thousand years ago.

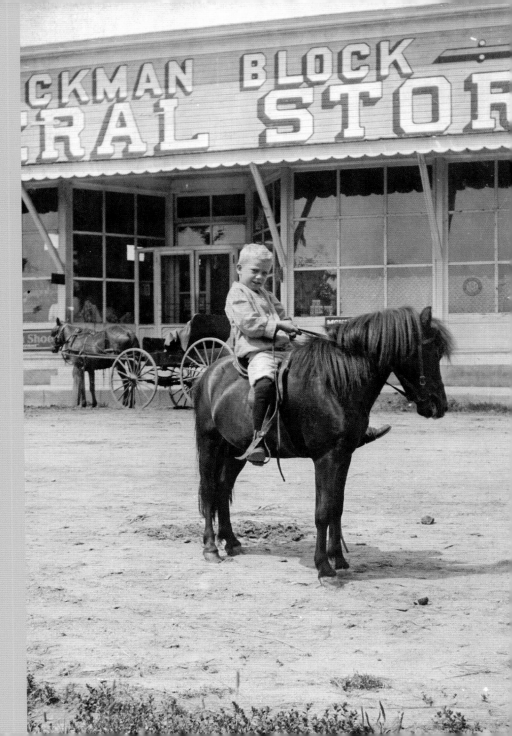

CIRCA 1910

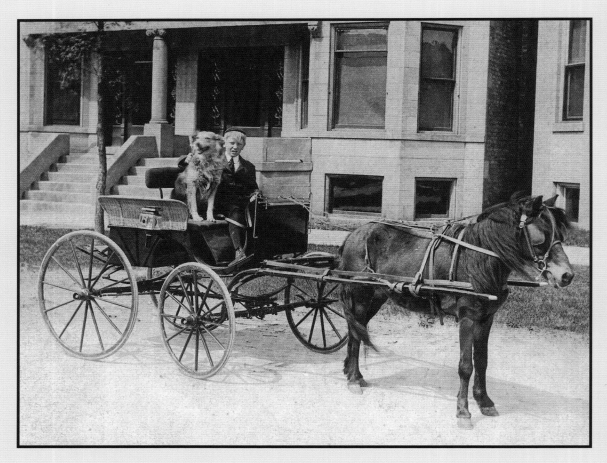

CIRCA 1900

A dapper young man *(above)* and confident young lady *(opposite)* have their ponies smartly in hand, with dog friends by their sides.

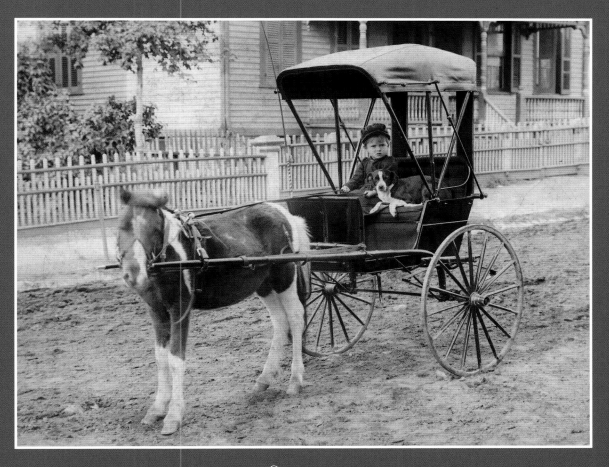

CIRCA 1890

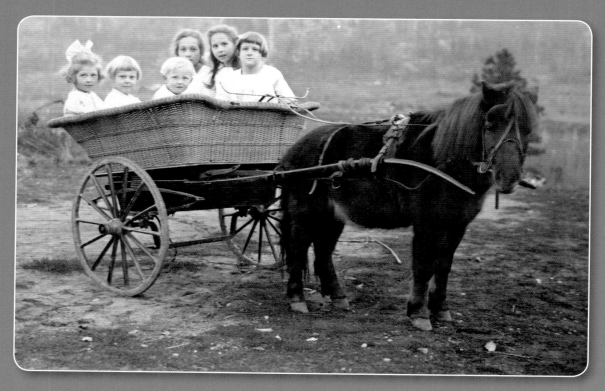

The Field cousins, Leavenworth, Washington, 1915

From left to right: Harriet, age 4; Jean, age 4; Jack, age 2; Ruth, age 9; Helen, age 7; and Frances, age 6. Harriet, Ruth, Helen, and Frances were sisters; their cousins, Jean and Jack, were brother and sister.

CIRCA 1900

The lightweight pony trap, also sometimes known as a dog cart, was a favorite of young children who could, with practice, drive it themselves. The young lady in this photograph is taking her father and her beautiful dolly out for a ride in a lightweight wicker cart.

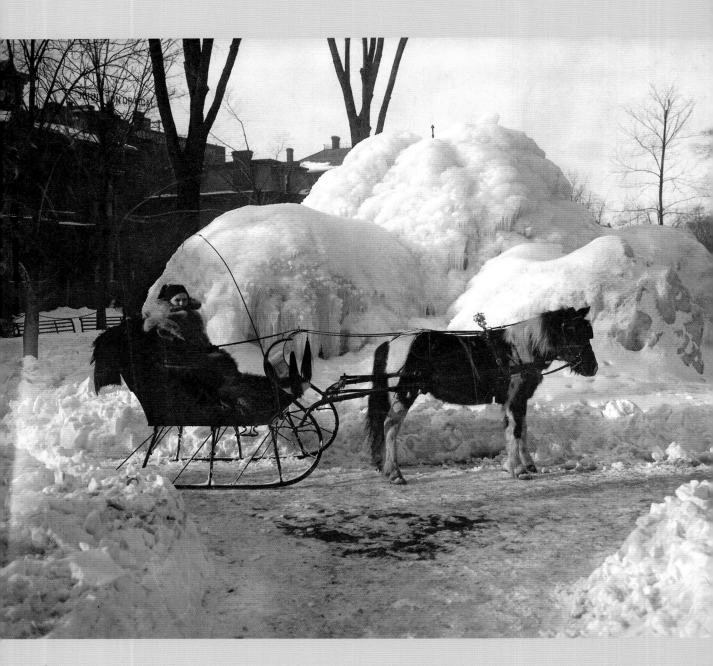

With love from Adelaide Dorothea Haberkorn, taken February 5th, 1901

Photographed by C.R. Baker, Detroit, Michigan

After an unseasonable warm spell lasting several weeks in January, a surprise snowstorm blanketed the city on the 1st of February. But it would take more than plunging temperatures and icy streets to keep Adelaide Haberskorn from taking the air at the Detroit Water Works in her one-horse open sleigh. This spectacular "iceburg" was formed by water freezing in mid arc before park custodians were able to shut off the fountain's water supply.

Although automobiles were already in mass production in "Motor City" by 1901, they were still no match for the famously frigid Michigan winters. Horses, on the other hand, could take the weather in stride, so to speak, thanks to Detroit's blacksmiths who made special shoes outfitted with spikes that provided needed traction on treacherously frozen roadways.

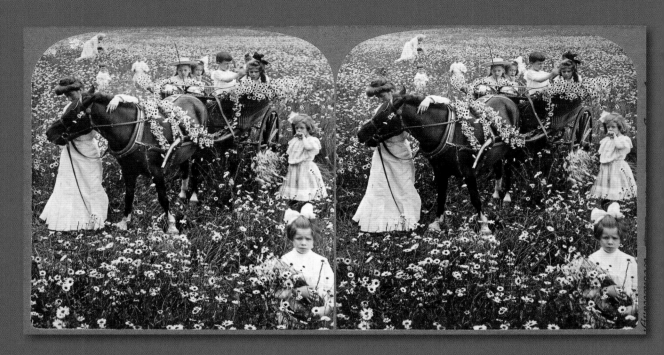

A Glorious Mayday Among the Daisies, 1904

This stereoview card was printed in New Jersey by a publisher with offices in Kansas, New York, Toronto, and London, and its title appears on the reverse side in six languages: English, French, German, Spanish, Swedish, and Russian! The popularity of the stereoscope cannot be exaggerated. From the 1880s until the early 1920s, a stereoscope and a collection of viewing cards could be found in almost every American home. Patented by Sir Charles Wheatstone in 1838, the viewing card is composed of two photographs taken from slightly different points of view that are mounted side-by-side. When seen through a set of lenses—the stereoscope—the two images converge into a three-dimensional single picture.

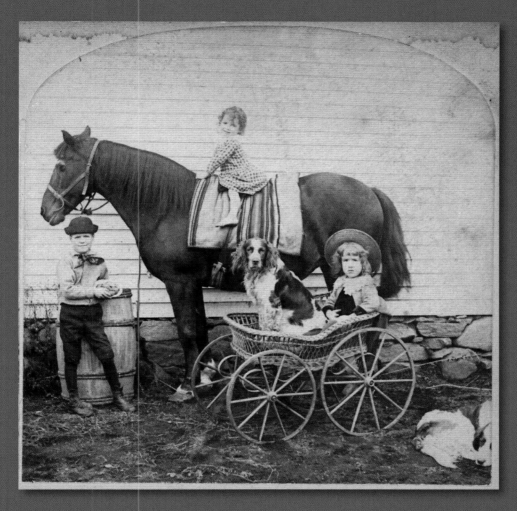

Dollies' Friends

Half of a stereo card, photographed by B.W. Kilburn, Littleton, New Hampshire, 1887

The Little Princes von Preßen

Photographed by Gustav Liersch & Co., Berlin, Germany

From left to right: Prinz Louis Ferdinand, born 1907, Prinz Hubertus, born 1909, and Prinz Friedrich, born 1911. Americans and Europeans were just as interested in the children of celebrities in the early twentieth century as we are in the early twenty-first century. The little Prussian princes, like all royal children, were popular subjects for photographers.

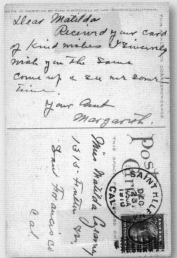

Dear Matilda,

Received your card of kind wishes.
I sincerely wish you the same. Come up
and see me some time.

Your Aunt Margaret

Postmarked December 23, 1910
St. Helena, California

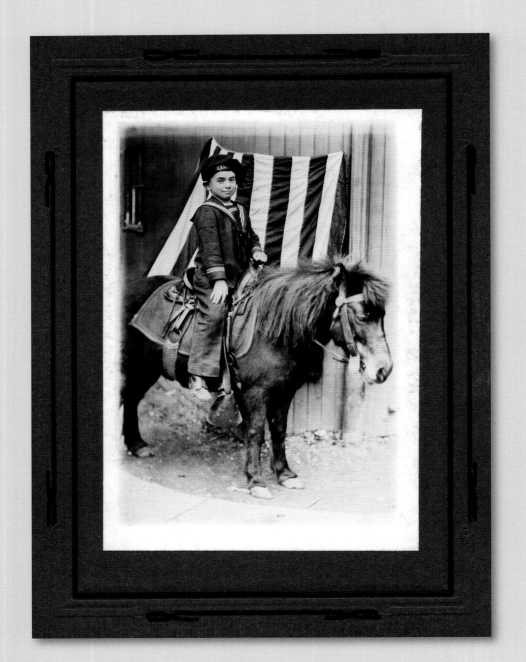

CIRCA 1915

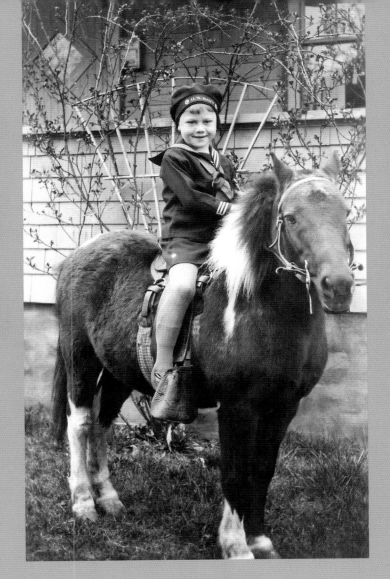

CIRCA 1915

(Above and opposite) The tunics and caps worn by these proud young men are child-sized replicas of the enlisted man's naval uniform that was in use until the end of World War I. The dark blue wool cap, which would be known as the "Donald Duck" after it was immortalized by a certain Disney character, was replaced in 1918 by the white cotton "jarhead" cap still in use today.

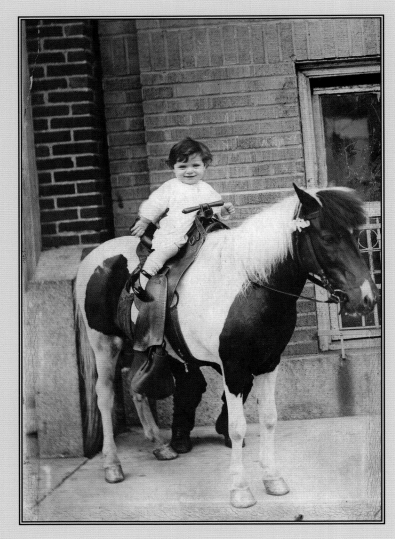

CIRCA 1920

Someone, possibly the photographer's assistant, is propping up this happy toddler, as evidenced by the trousered legs that can be seen behind the pony. The pommel on the saddle has been modified with extended handlebars for small hands to clutch.

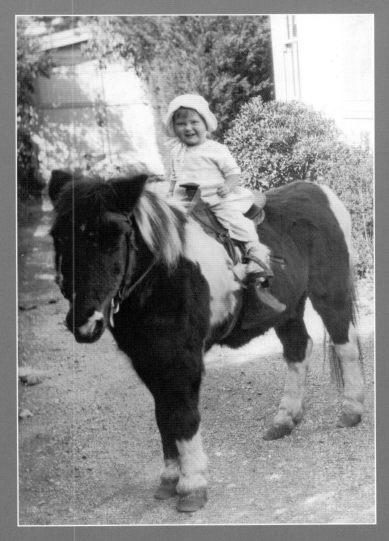

CIRCA 1920

When left to nature, small stature in horses is dictated principally by environment. Severe climate conditions and scarce, poor forage encourage a short, stout body type; an extremely dense coat; a heavy mane and tail; shaggy fetlocks; and small, tough hoofs.

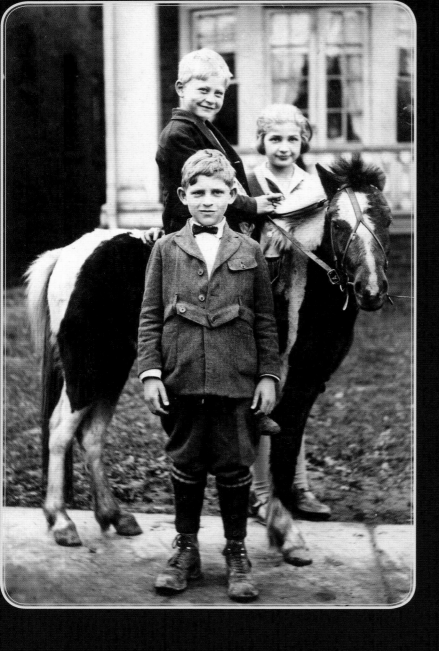

The Squirrels,
Chicago, 1925

CIRCA 1915

Professionally produced cabinet cards were enormously popular from the 1880s through the 1920s and were exchanged to commemorate important events such as birthdays, weddings, and holidays.

CIRCA 1920

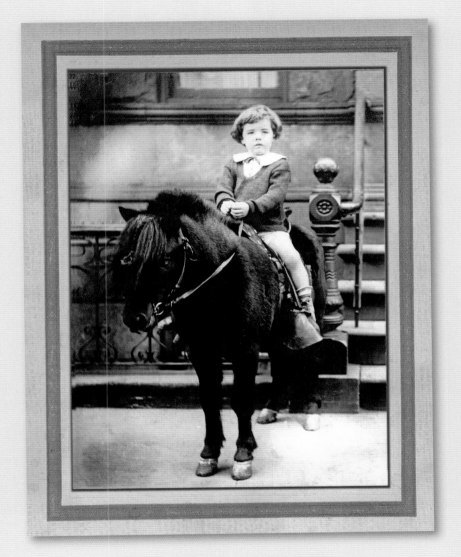

Alan Anderson, age 4, New York City, 1922

The Manhattan brownstone in the background was Mr. Anderson's home until 2003 when he moved to southern California, where he lives today.

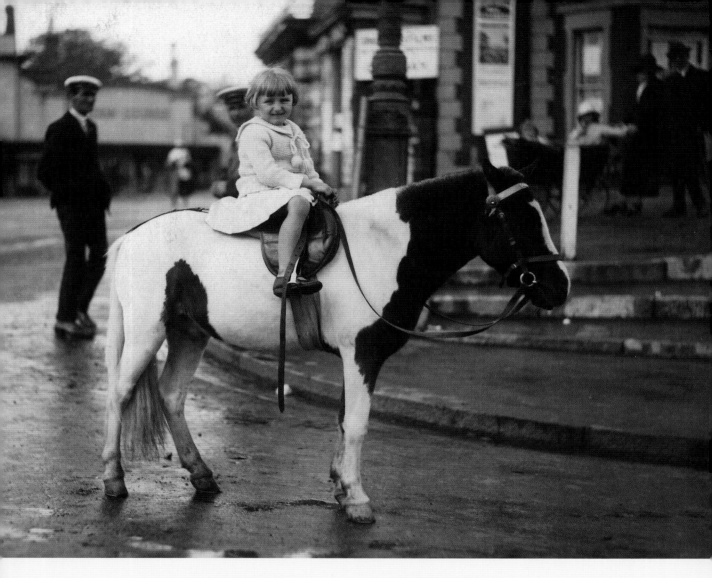

CIRCA 1925

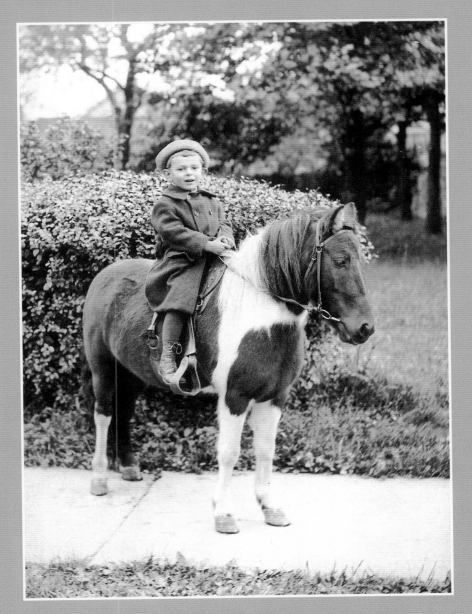

CIRCA 1925

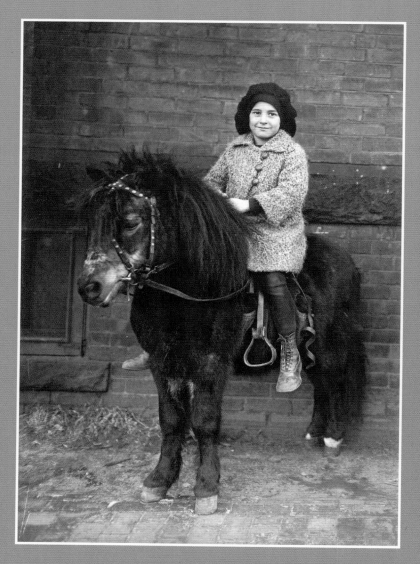

CIRCA 1925

(Above and opposite) Although photographed in different places at different times of the year, it is clear that it is the same pony in both pictures.

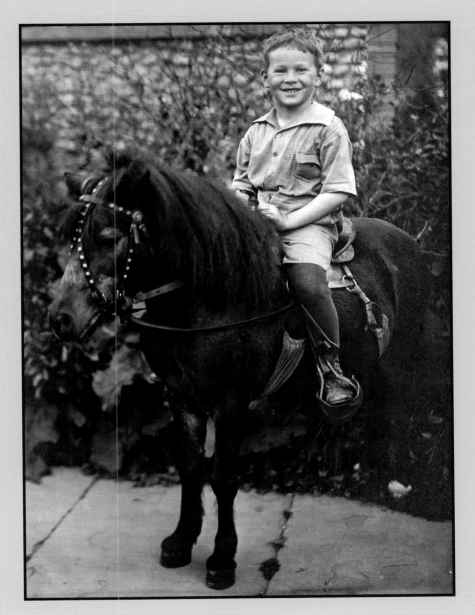

CIRCA 1925

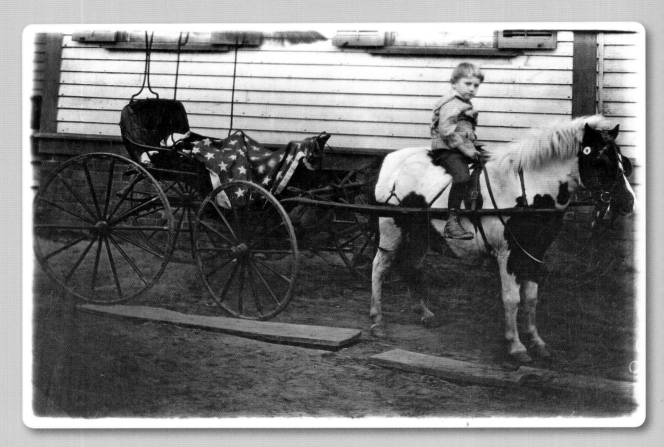

July 4th, 1911

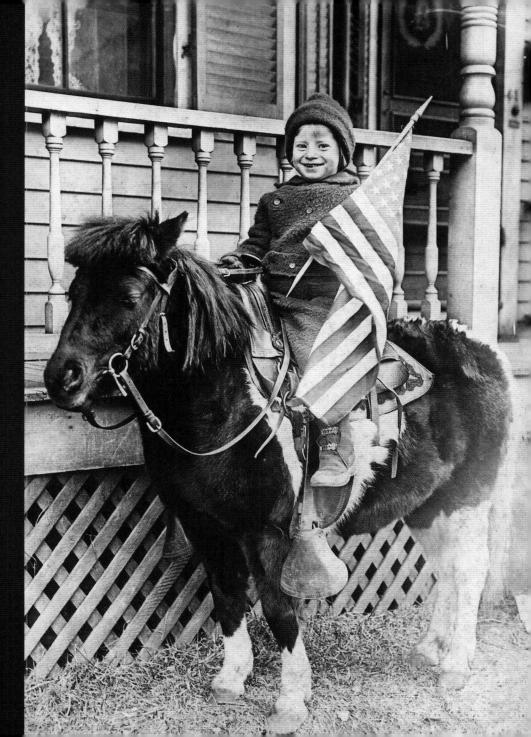

CIRCA 1920

**With love and many
Happy Easter wishes
from all the B's**

Note the elaborate
letter "B" on
the screen door
of the house.

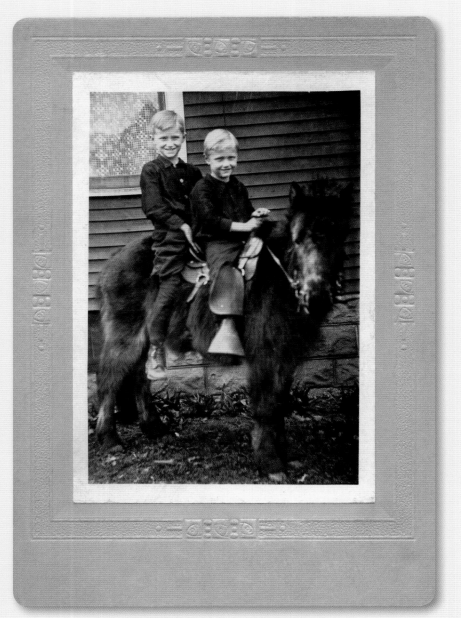

There were many reasons children enjoyed being photographed on ponies and chief among these was the emulation of the cowboy. America's cowboy heroes were born out of the incredibly popular "dime" novels of the 1860s. Many of these fictional characters were based on the real-life exploits of late eighteenth and early nineteenth-century frontiersmen who fought hostile Indians, survived bear and mountain lion attacks, and performed near-superhuman deeds, including racing across a largely untamed continent for the Pony Express.
(*Continued on page 57*)

Circa 1925

The cowboy was in reality a transient laborer moving herds of cattle, horses, or sheep across the mountains, plains, and deserts of the West and Southwest. It was a lonesome, dirty, often dangerous job. But thanks to historic predecessors like Daniel Boone (1734–1820), David Crockett (1786–1836), and James Bowie (1796–1936), the cowboy was gradually mythologized into an icon of America's fiercely independent spirit and a role model for children as a hero of the wild West.

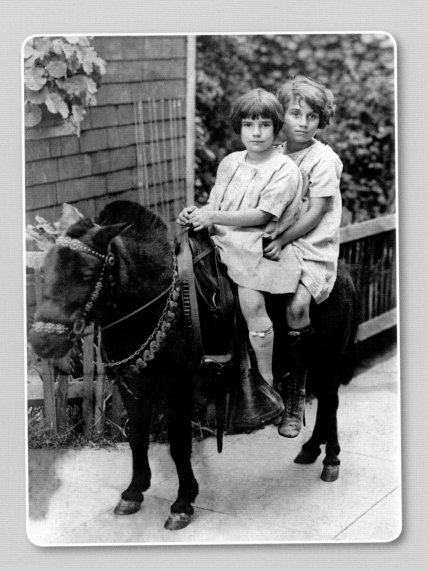

57

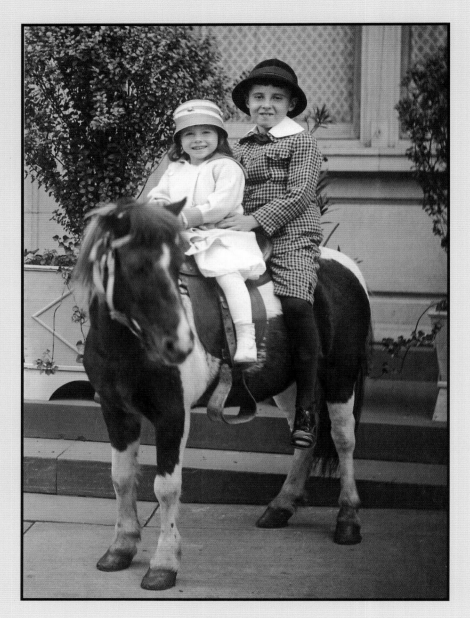

CIRCA 1920

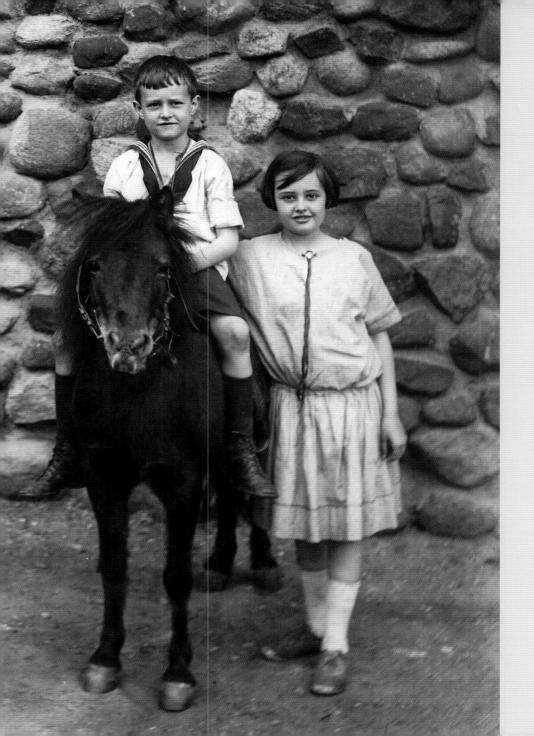

CIRCA 1925

59

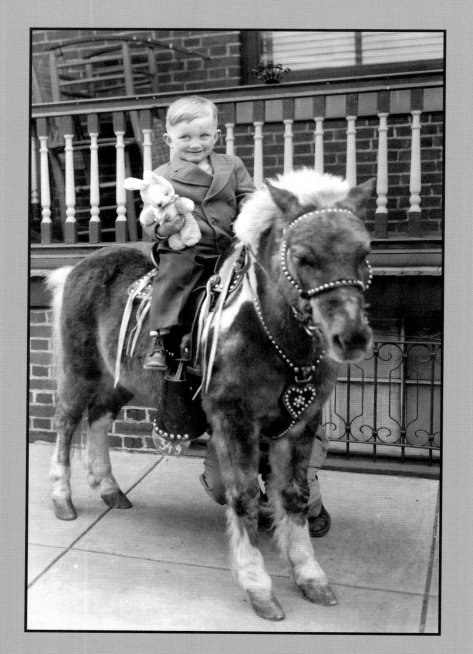

CIRCA 1930

Many photographers outfitted their ponies in fancy tack made from custom-dyed leathers and decorated with German nickel-plated studs, known as "spots."

CIRCA 1930

Children were often dressed
in their very best clothes to have
their pictures taken and were
sometimes accompanied by
special "friends."

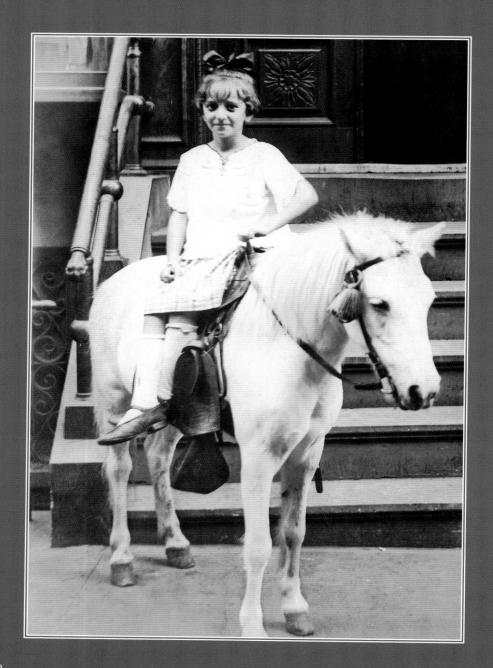

CIRCA 1920

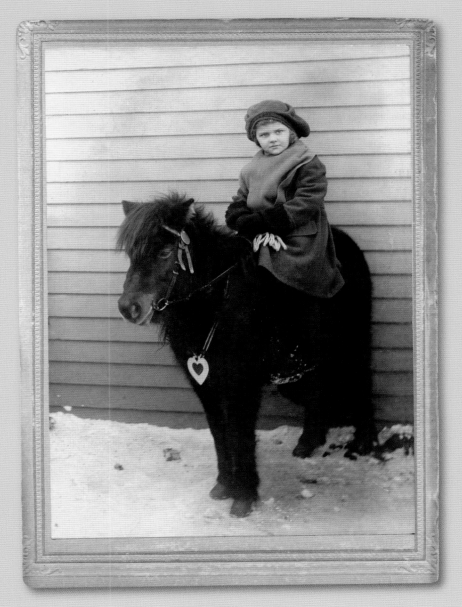

CIRCA 1935

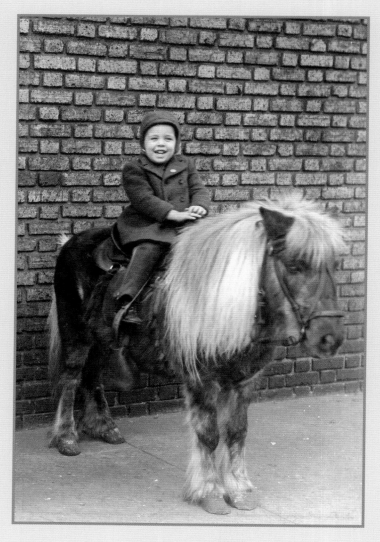

CIRCA 1930

Following the stock market crash of 1929, Americans sought relief from the harsh realities of the Depression—and they found it at the movies. Throughout the 1930s, movie houses offered matinees for only 5 or 10 cents and Westerns were by far the favorite fare for kids.

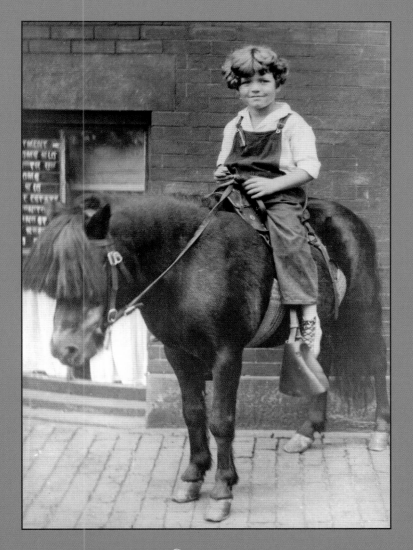

CIRCA 1930

Many of the cowboy heroes of Victorian fiction were recycled and renewed for radio and silent films during the 1920s and early 1930s. A few of them would later catapult to even greater stardom thanks to the movies of the 1930s and 1940s and, later, the television shows of the 1950s and early 1960s.

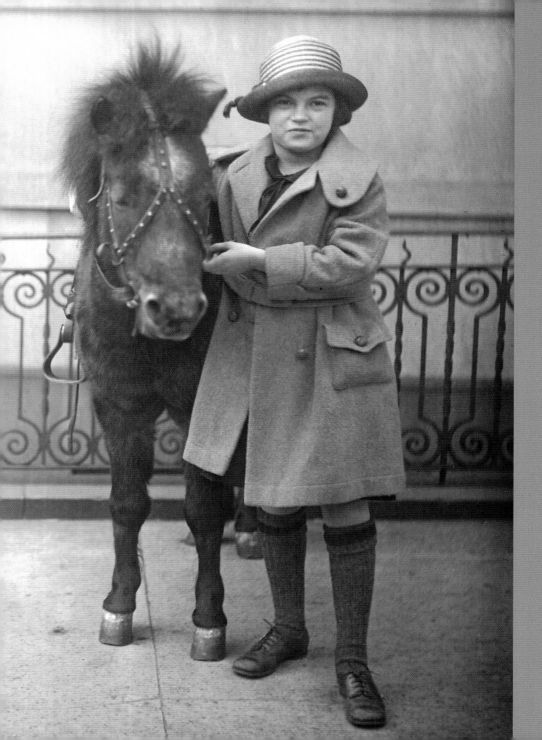

CIRCA 1930

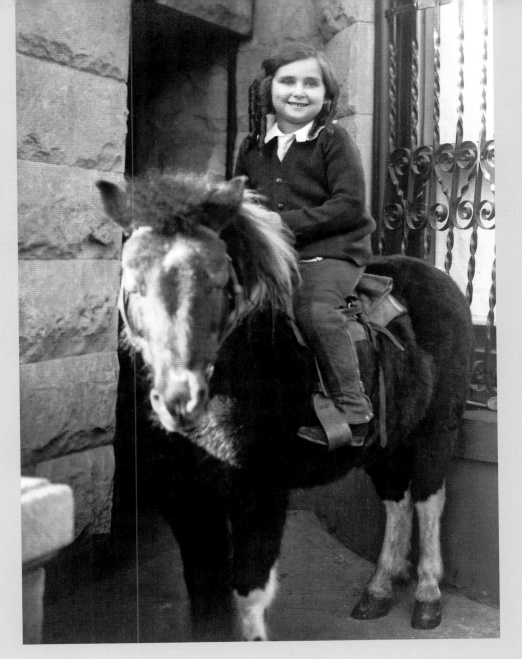

CIRCA 1930

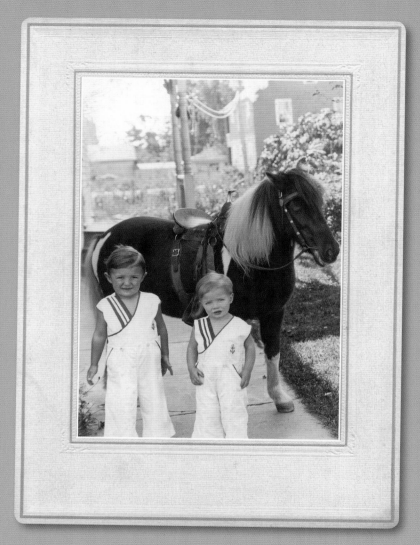

CIRCA 1935

Since the domestication of horses, humans have been selectively breeding for size, from truly miniature horses measuring no more than 35 inches at the withers and weighing barely 100 pounds, to the great draft breeds that tower over 6 feet and weigh nearly a ton.

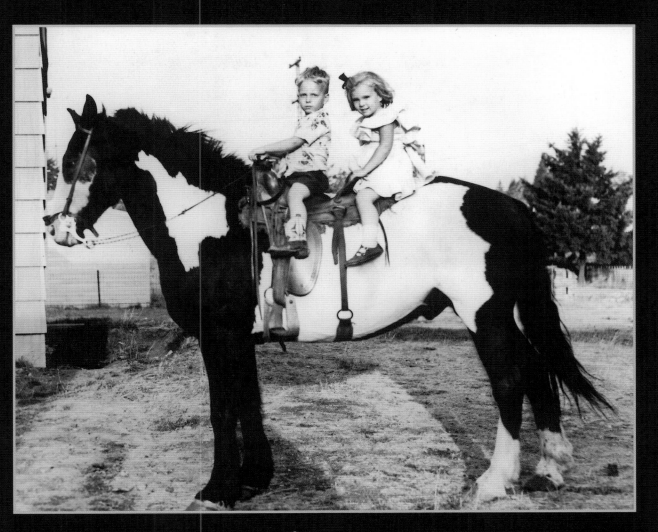

CIRCA 1935

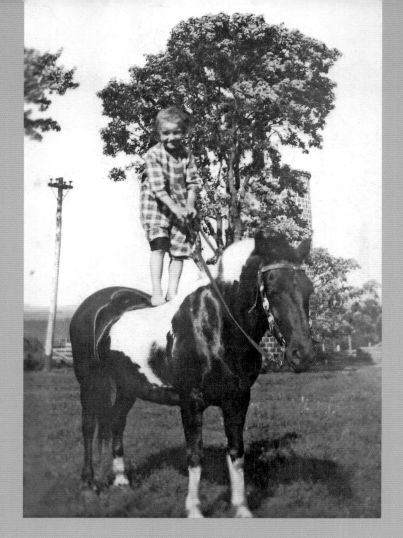

CIRCA 1935

Hopalong Cassidy was the hero of 28 novels by Clarence E. Mumford. William Boyd was a silent film actor who made 35 features, beginning in 1933, based on Mumford's character. Boyd and his quarter horse Topper were beloved by boys and girls across America and went on to star in a successful television series that ran for 99 episodes between 1949 and 1951. At the height of their fame, man and horse received a staggering 15,000 letters a week from adoring fans like the aspiring trick rider (*above*).

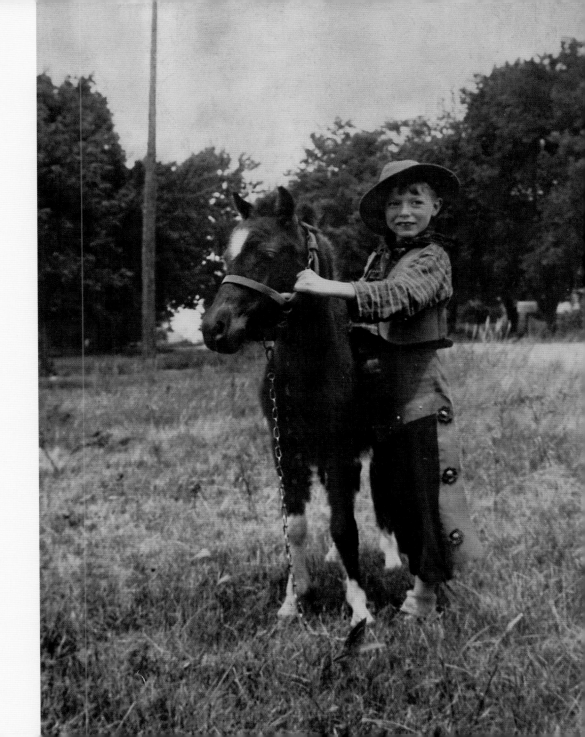

CIRCA 1934

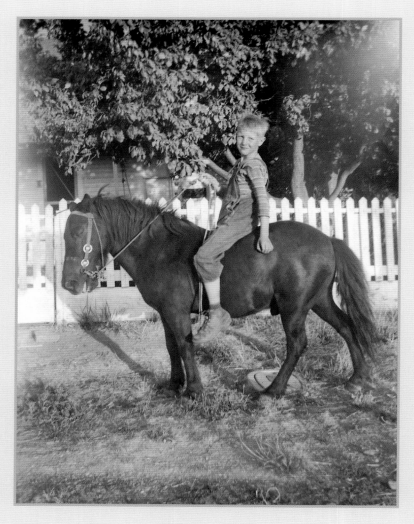

CIRCA 1935

Gene Autry was one of the first "singing cowboys" who, with his trick horse Tony, made a number of hugely popular films in the 1930s. His television show debuted in 1950 and ran for six years. Gene Autry wanted to be a role model for children and lived by his own Cowboy Creed, which he distributed copies of to theatres, schools, and churches across America.

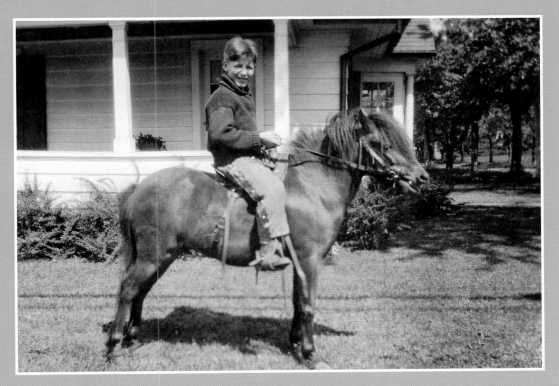

CIRCA 1935

Gene Autry's Cowboy Creed

 1) A cowboy must not take unfair advantage of an enemy.

 2) He must never go back on his word.

 3) He must always tell the truth.

 4) He must be gentle with children, elderly people, and animals.

 5) He must not possess racially or religiously intolerant ideas.

 6) He must help people in distress.

 7) He must be a good worker.

 8) He must respect women, parents, and his nation's laws.

 9) He must neither drink nor smoke.

10) He must be a patriot.

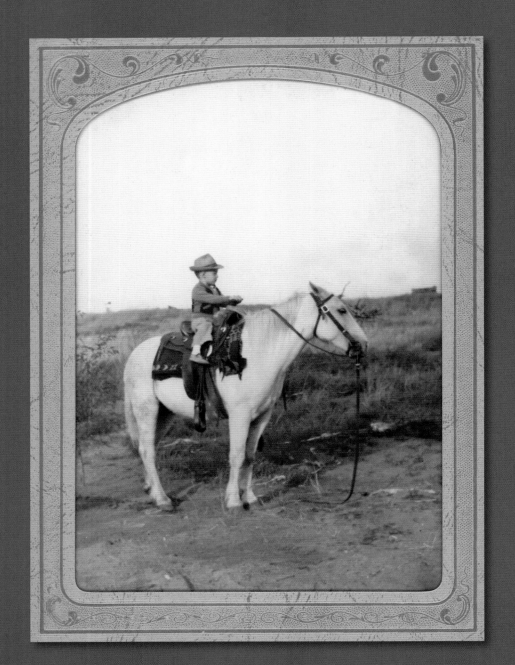

CIRCA 1925

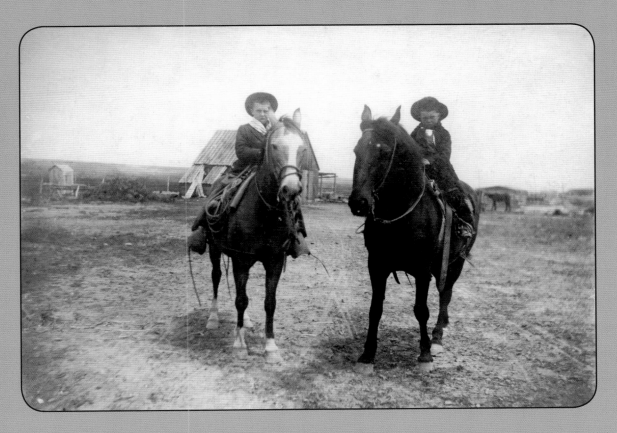

CIRCA 1915

(*Above and opposite*) These young men didn't have to aspire to being like cowboys from books or the movies—they are riding real cow ponies on the actual prairie.

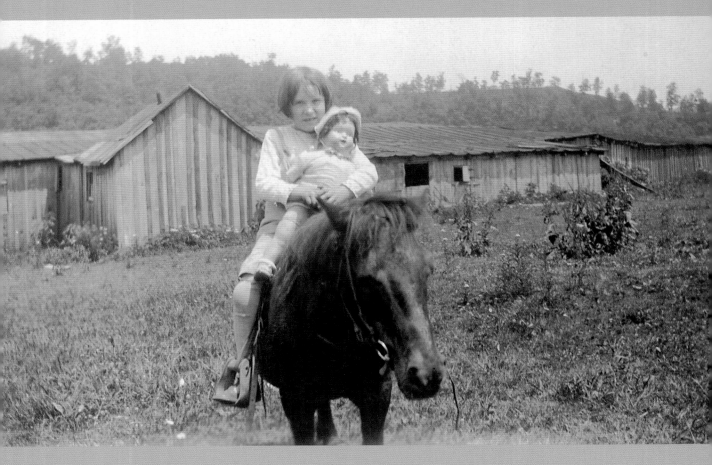

Circa 1925

For John

To children growing up in rural America during the early decades of the twentieth century, horses were still ubiquitous. The Great Depression of the 1930s put modern equipment out of reach for most small farms, while even just one horse could vastly increase a farmer's productivity. This young lady and her dolly pose bashfully on a farm pony.

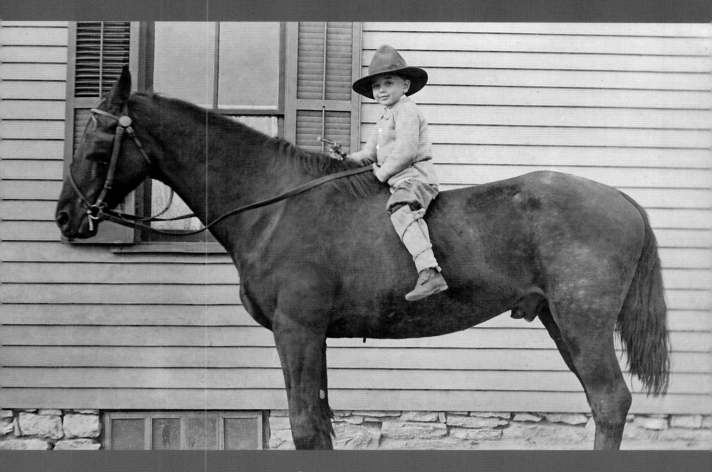

CIRCA 1920

The hat worn by this young man would have belonged to a cavalry officer and is the style still worn by U.S. Army drill sergeants today—and by the most famous and sharply dressed bear in America, Smokey. It is commonly assumed that the cavalry had phased out their horses by the conclusion of World War I, but, in fact, there were some 12 million horses and 4.5 million mules serving in the armed forces at the start of World War II. The last horsed cavalry unit that saw combat was the 26th regiment of Philippine Scouts who fought in Bataan in 1942.

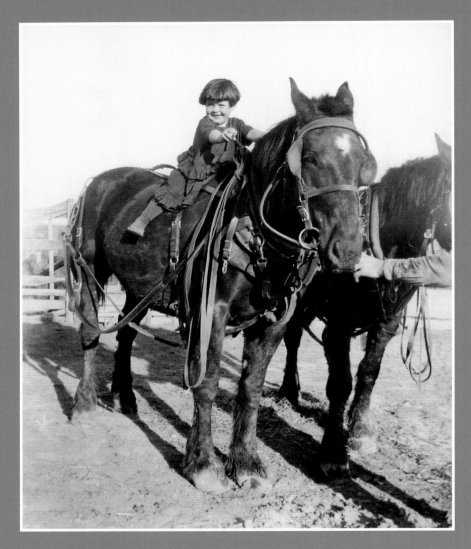

CIRCA 1930

A multi-purpose horse was the single most useful piece of "equipment" on any family farm. It is no accident that the power of the first steam engine was measured in horsepower, a term coined by its inventor James Watt in 1769.

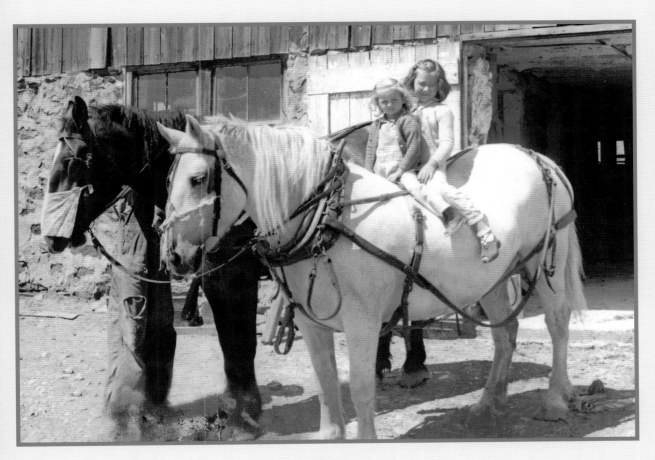

CIRCA 1935

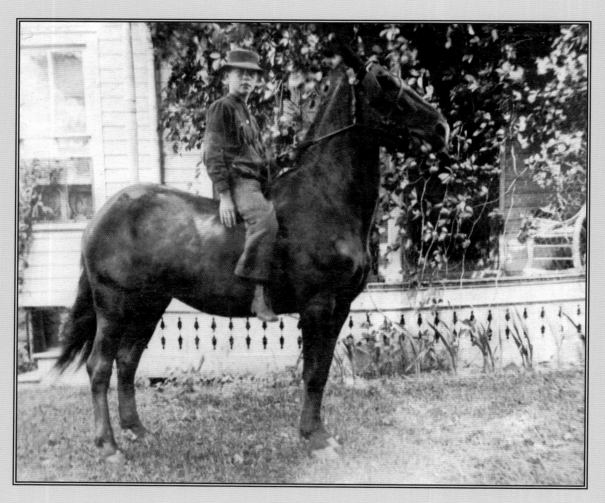

Circa 1920

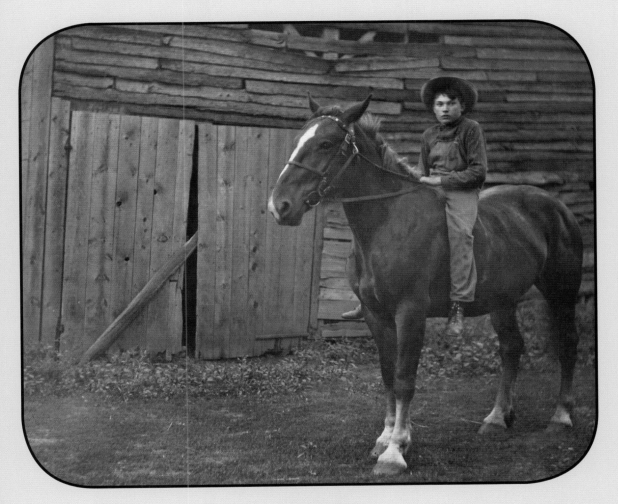

CIRCA 1920

Floyd Brown, Aunt Lib Dwitzer's son

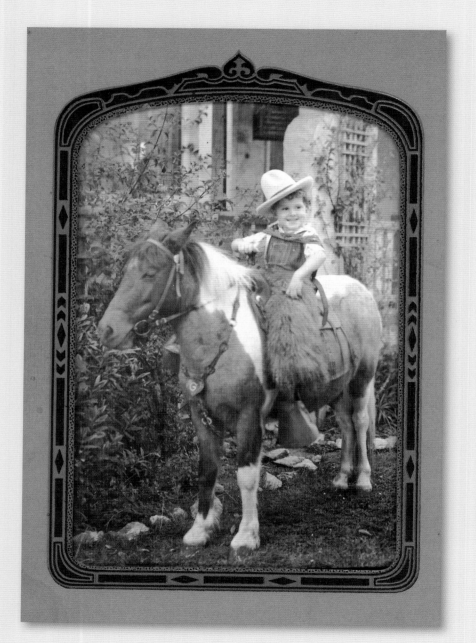

CIRCA 1930

The cabinet card was eventually replaced by another photo presentation: a custom cardboard mat, often embossed or imprinted with a design, that was glued to one end of a cardboard backing; the photo print slid neatly inside where it was both nicely framed and protected. Some photographers used the decorative mats to advertise their studios, and by the 1920s, elaborately folding envelopes, often beautifully imprinted, had been developed. A vertical photo was sometimes presented in an envelope that cleverly unfolded into an easel, so that the print could stand alone in its self-frame.

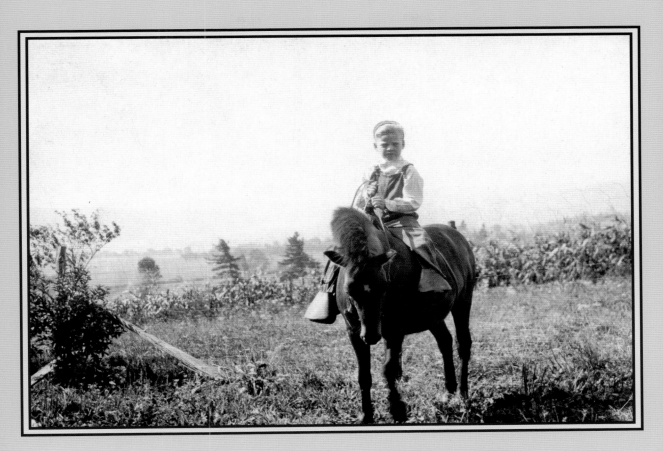

Crandall Miller and his pony on the farm, September 3, 1929

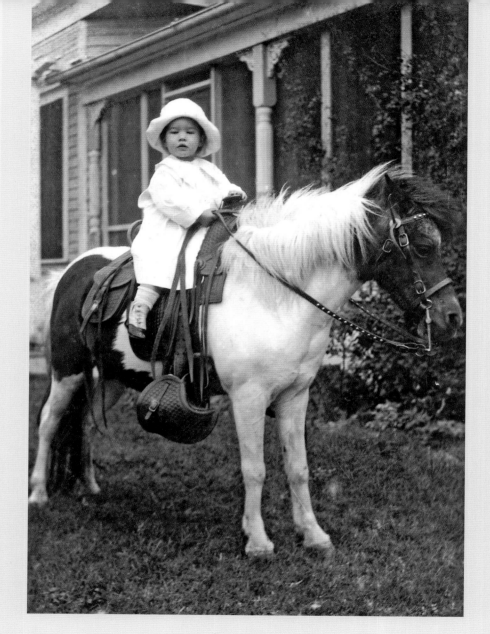

CIRCA 1935

With lots of love from your partner Billy

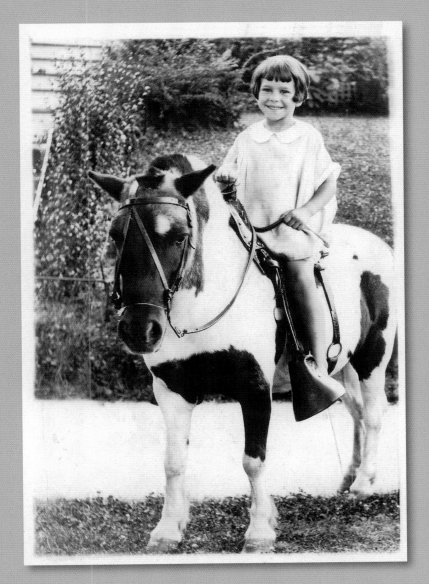

CIRCA 1930

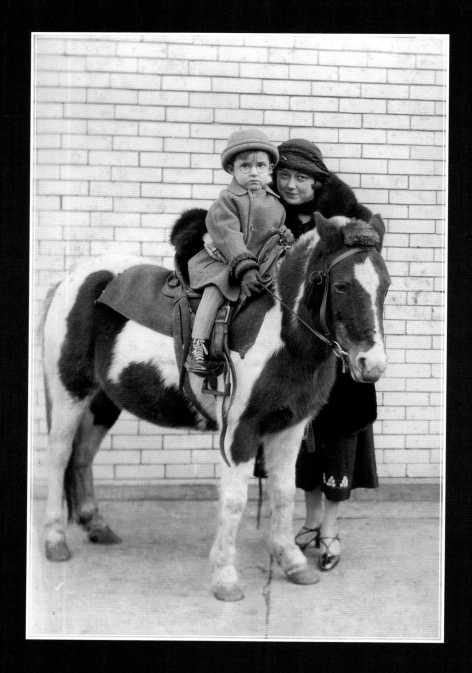

CIRCA 1930

Ann Wahl,
cousin of Agnes,
daughter of
Carrie Andrews Ogburn,
and Jack

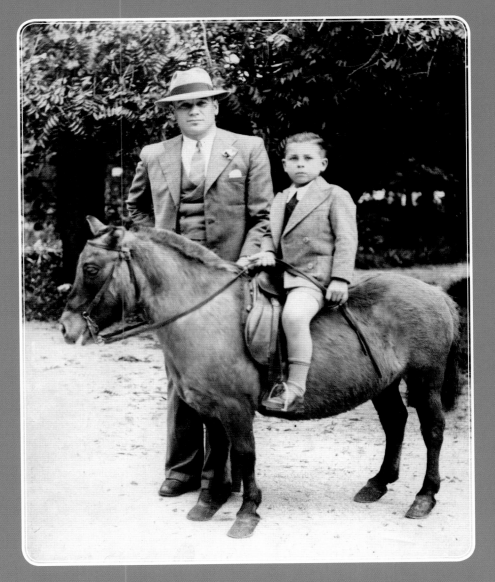

CIRCA 1930

Recuerdo del Paseo Jardin Zoologico, La Plata, Buenos Aires, Argentina

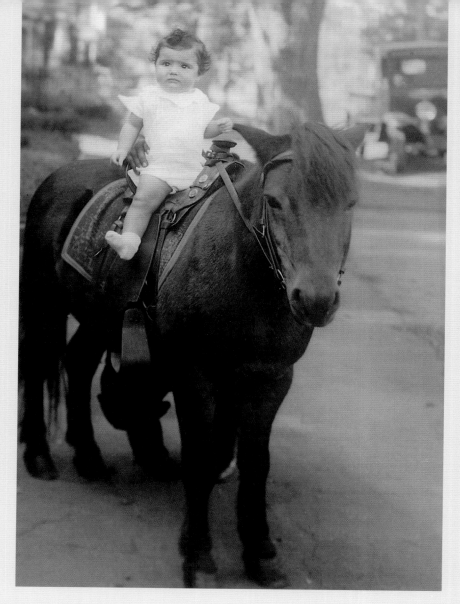

(*Above*) Roberta Hozer Lurie, age 1, New Haven, Connecticut, 1936, and (*opposite*) Judith Willensky Siperstein, age 3, Bayonne, New Jersey, 1936. Roberta and Judy were photographed the same year on the same pony by the same photographer in different states.

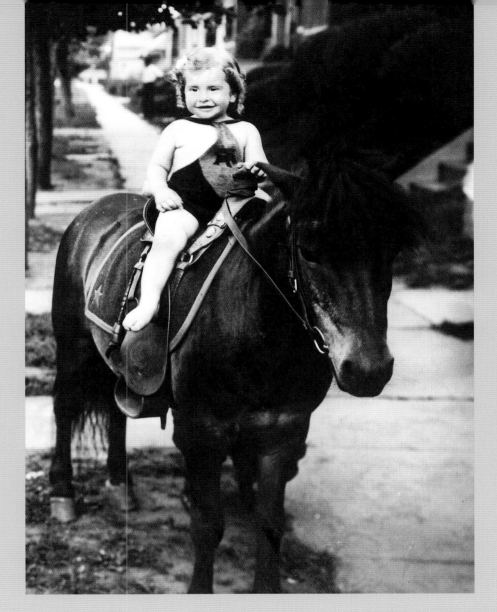

Roberta's son Steven Lurie met Judy's daughter Bonnie Siperstein in 1986; Steven and Bonnie were married in 1988. Roberta and Judy remain close friends to this day.

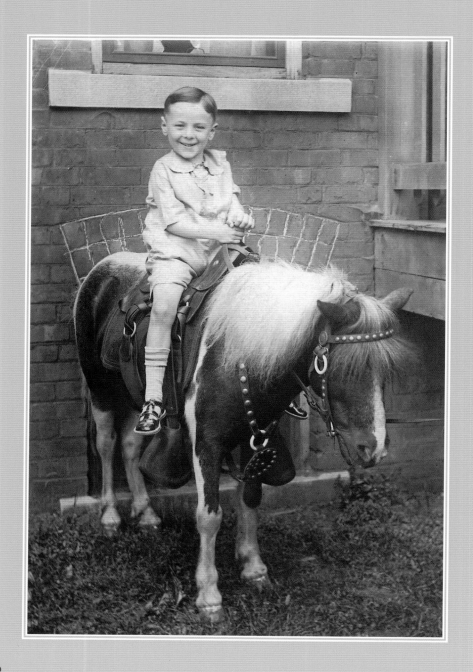

CIRCA 1935

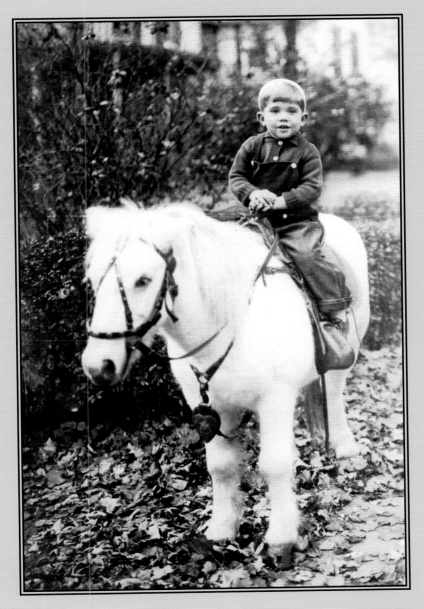

C. Edgar Champrenois Jr., East Orange, New Jersey, 3¹/₂ years old, October, 1936

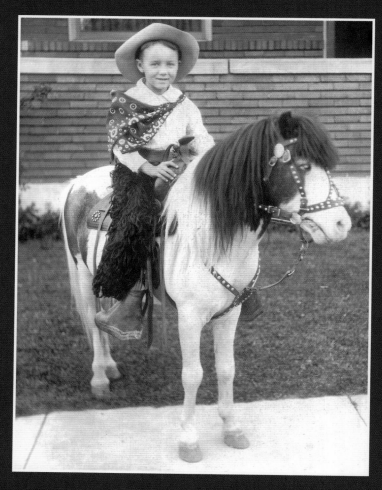

CIRCA 1935

Vaquero, the Spanish word for cowboy, was a term first used by sixteenth-century Mexican cattle ranchers. The men who drove the enormous herds across the vast expanses of the southwestern plains rode tough little "mustangs," feral horses that had evolved from those brought by the conquistadors. The original Spanish imports had been bred for centuries in the arid, semi-desert conditions of the Iberian Peninsula, thus their hardy descendents were perfectly suited to the harsh conditions of the New World.

CIRCA 1930

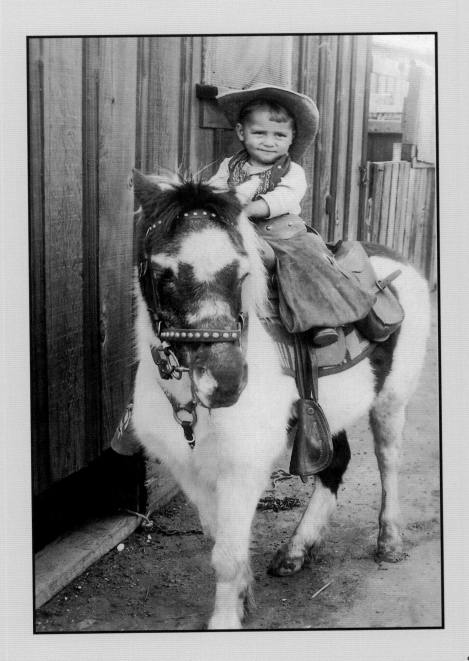

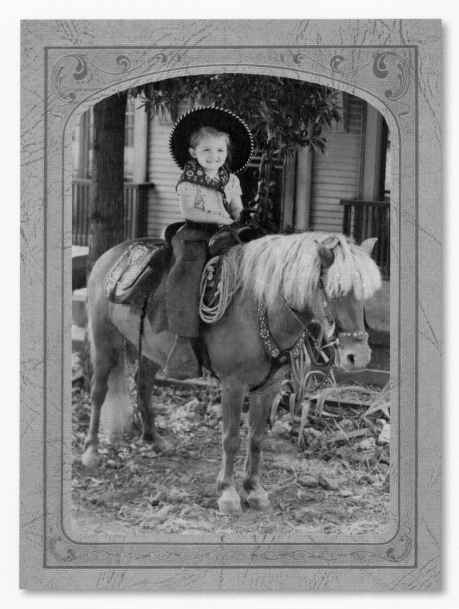

CIRCA 1945

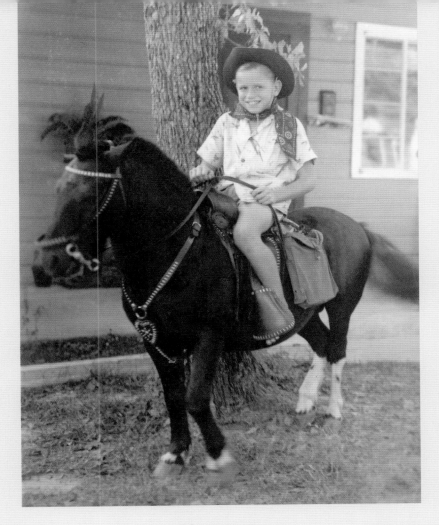

CIRCA 1945

The "western" or "stock" saddle is basically a conquistador's saddle, with a few key adaptations: narrow stirrup leathers were replaced by wide leather "fenders" designed to be a sweat barrier between horse and rider; the stirrups themselves became wider, heavier, and were augmented by *tapaderos,* thick leather covers for extra boot protection in rough terrain; and, most significantly, the addition of a second "bucking" cinch, insurance against a saddle being snagged and pulled off a horse—and the rider with it—and the "horn" attached to the saddle's pommel from which to anchor a lariat or rope.

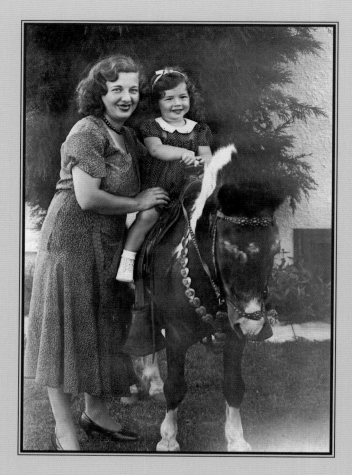

CIRCA 1939

National Velvet, published in 1935, tells the story of a teenage girl with dreams of winning England's Grand National steeplechase on her headstrong piebald gelding. Disguised as a boy, Velvet Brown rode "the Pie" to victory—and encouraged little girls everywhere to dream big. In 1944, the book became a wildly successful movie starring twelve-year-old Elizabeth Taylor, who did almost all of her own riding in the film. MGM studios gave the horse that played Pie to Ms. Taylor as a gift. From 1960 to 1962, a television series based on the book inspired girls all over America to take up English-style riding and jumping.

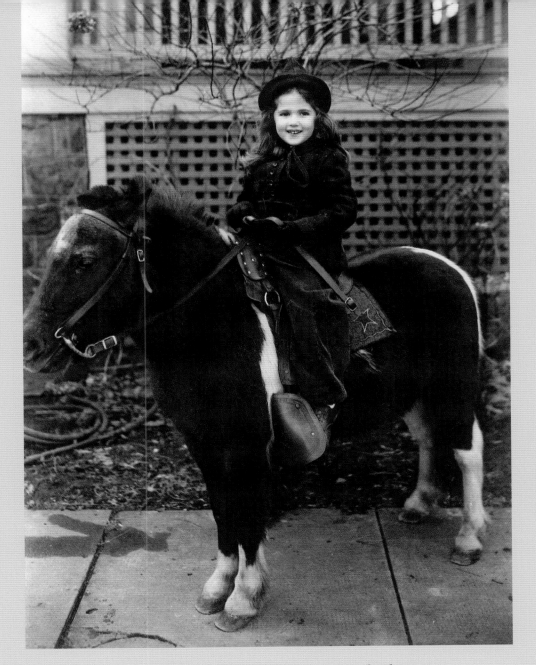

Sandra Fish Katsoff, age 4, Baltimore, Maryland, 1939

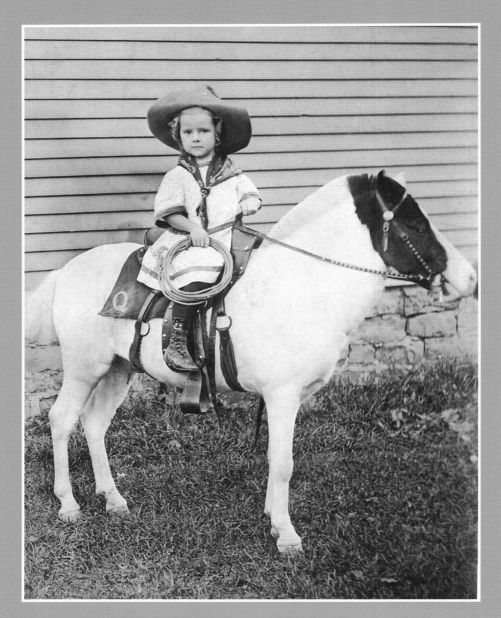

Circa 1930

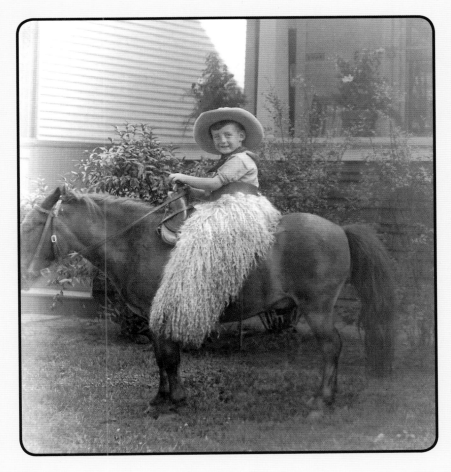

CIRCA 1930

Chaps, or *chaparejos,* are leather leggings developed by Mexican cowboys to protect their legs from the punishing cactus thorns of the Sonoran desert. American saddlemakers and leatherworkers eventually developed four distinct designs: "shotguns" completely encased the entire leg and were so-called because they resembled the barrels of a shotgun; sheepskin "woolies" covered the front and sides of the legs and were favored by stockmen working in the cold northern territories; "batwings" featured large, loose cowhide or leather flaps that were often decorated with tooled or appliquéd designs and trimmed with leather fringe or metal spots; "chinks" were shorter versions of batwings.

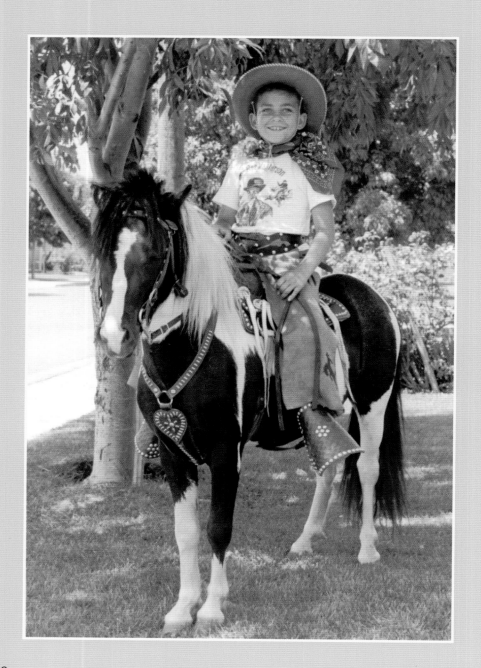

CIRCA 1944

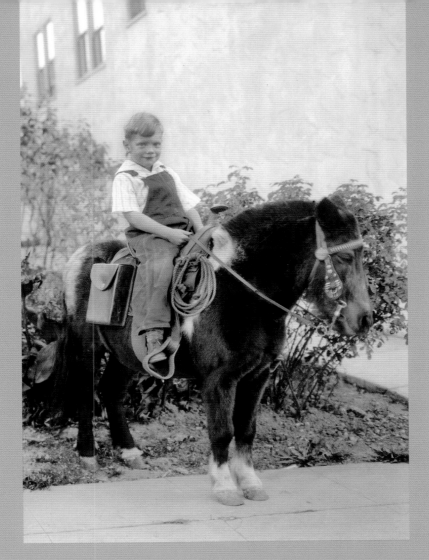

CIRCA 1942

Mary O'Hara's 1941 classic novel *My Friend Flicka* chronicles the relationship between Ken McLaughlin, son of Wyoming rancher, and a wild filly. Ken's gentle training, in direct opposition to his father's traditional cowboy method of "breaking" horses, is at the heart of the story. In 1943, a film version starring Roddy McDowell was made, followed by a television series that first aired in 1955.

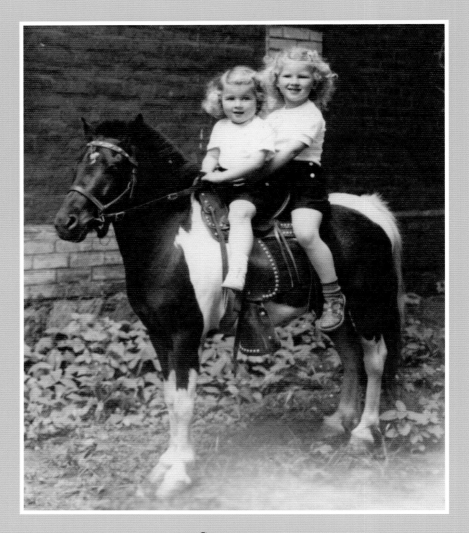

CIRCA 1944

(Opposite) The hackamore bridle evolved from the Spanish *jáquima,* which used a rough rawhide noseband for control instead of a bit in the horse's mouth. The modern hackamore squeezes the pony's nose when the reins are pulled, signaling him to slow down or stop. It is very unusual to see a hackamore used on a rental pony.

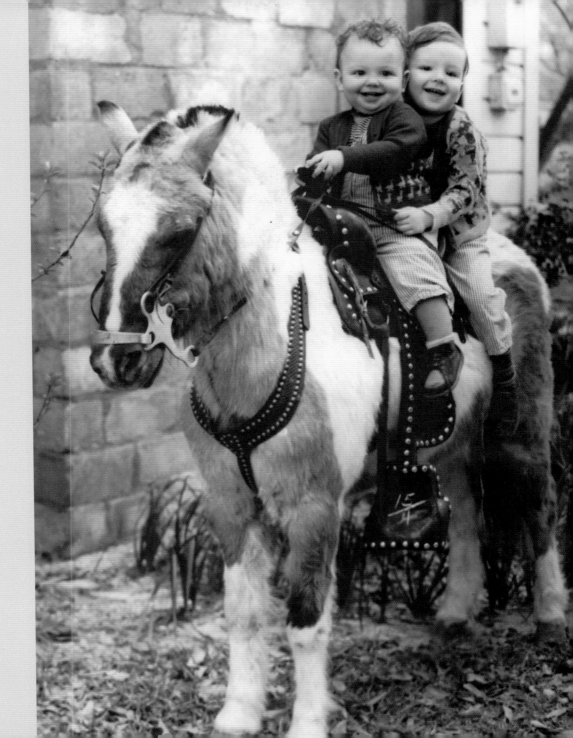

CIRCA 1950

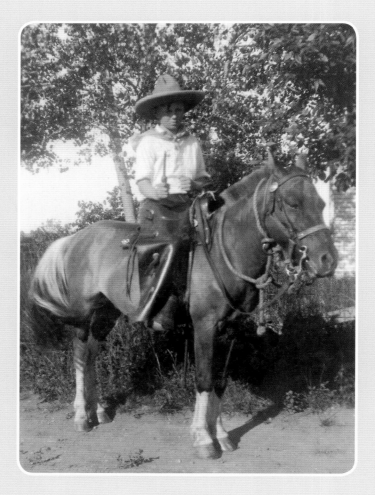

CIRCA 1940

No doubt, early Spanish cowboys, or *vaqueros,* wore *sombreros*—*sombra* is the Spanish word for shade—to ward off the burning desert sun. Until John B. Stetson made the classic "Boss of the Plains" hat in the late 1860s, the first American cowboys probably wore either sombreros or cavalry-style hats and caps left over from the Civil War. The Stetson, built of beaver felt to provide protection from rain and sun, was an immediate success, and remains popular to this day with cowboys and cowgirls of all ages.

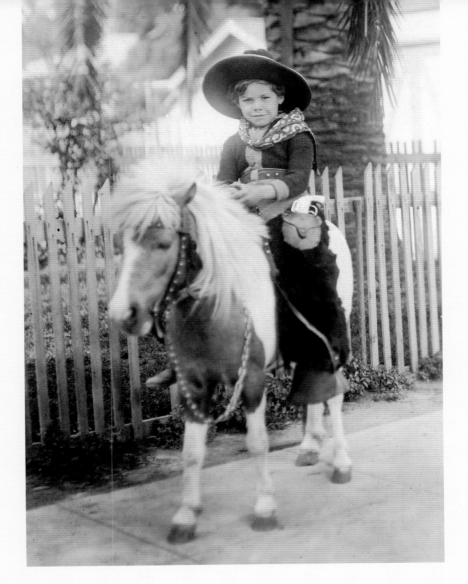

To Cuco and Rueida,

My son when he was dressed up like the cowboys—

Hector M. Rodriguez,
San Pedro, California, 1930

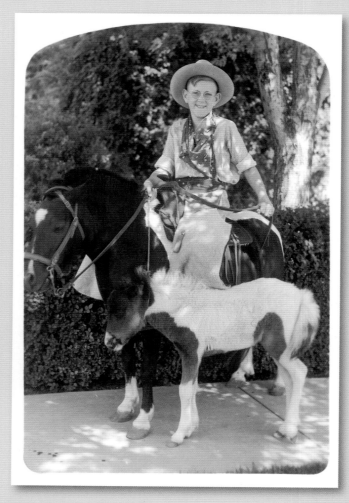

CIRCA 1945

Originally made as a radio show in 1938, *The Lone Ranger* became a fifteen-part movie serial that was such a hit, that a series of sequels soon followed. From 1949 to 1965, *The Lone Ranger* reigned as one of the most popular television Westerns of all time. Clayton Moore, riding a magnificent gray stallion named Silver, starred as the "masked man." His trusted friend Tonto, a rare example of a "good" Indian character, was played by Jay Silverheels, who rode an Indian paint pony called Scout.

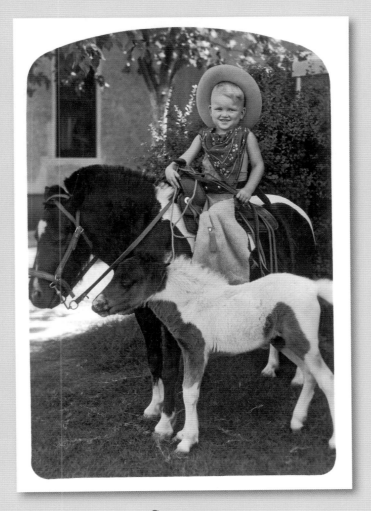

CIRCA 1945

(Above) **To Aunt Agnes & Glen from Jimmie Bob, 3 years and 5 months, weight 32 pounds, height 38 inches and** *(opposite)* **Charles**

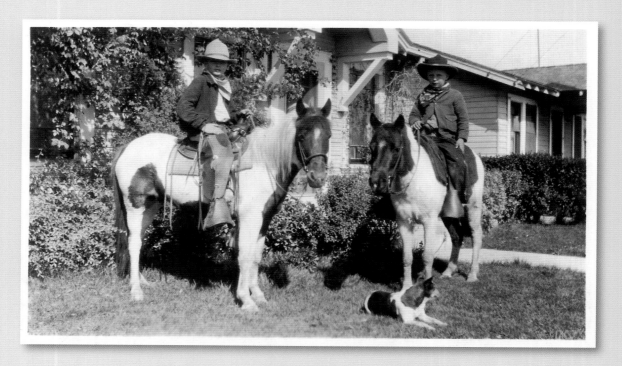

CIRCA 1945

(*Above and opposite*) Summer camps and dude ranches popped up all over America after World War II. Many were working cattle ranches looking to supplement a seasonal income. For city and suburban children it was their first opportunity to experience the lifestyle of their cowboy heroes.

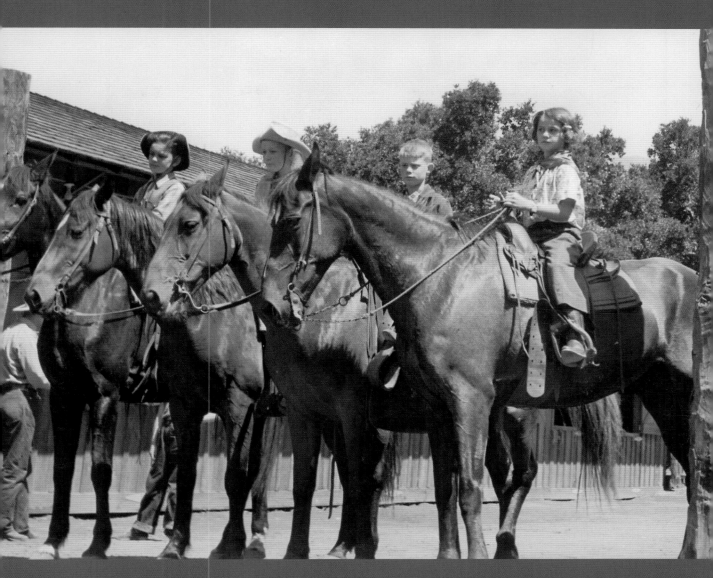

Circa 1945

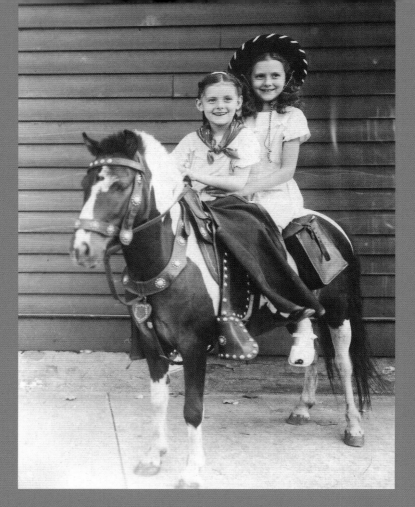

CIRCA 1945

(*Above*) These sisters, in a shared cowgirl costume, no doubt felt every bit as glamorous as their cowgirl movie heroines. (*Opposite*) Boys and girls of all races loved Westerns and played at being cowboys and cowgirls. The few African–American film producers of the time made a handful of movies that featured black cowboy characters, but, sadly, these films received meager distribution as most theater owners of the day were white. Historically, however, America has a proud tradition of black cowboys, including Nat Love, Bronco Sam, singing cowboy Charley Willis, and Bulldog-gin' Bill Pickett, who is credited with inventing the sport of bull dogging and was honored with a commemorative postage stamp in 1994.

CIRCA 1948

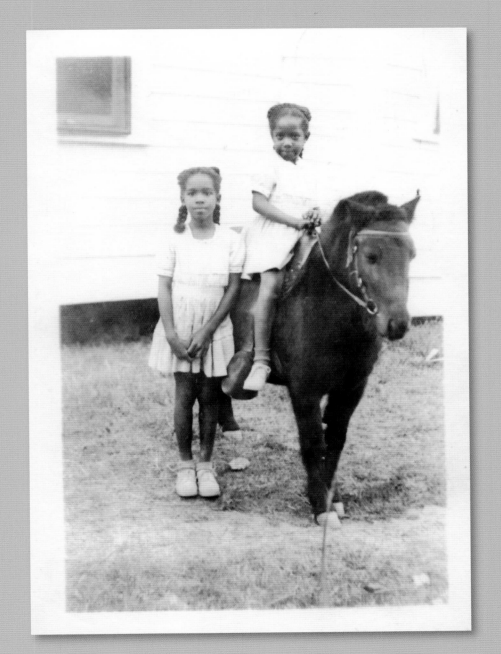

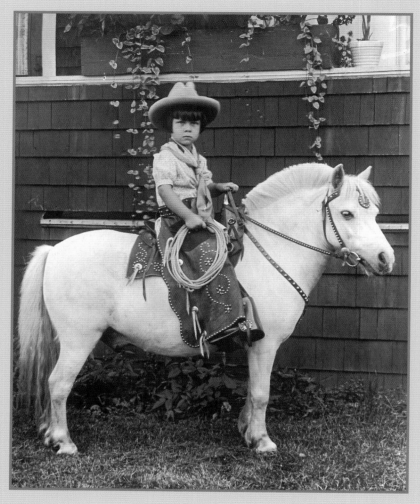

CIRCA 1945

The fancy saddles worn by equine movie stars like Topper, Tony, Silver, and Trigger featured decorative embossing, or "tooling," and became popular, not only on fancy parade and rodeo saddles, but on everyday working saddles as well. Engraved or stamped silver *conchos*—silver or nickel-silver rondells—were also used to decorate saddles and bridles to delightful effect when replicated for a pint-sized pony and rider.

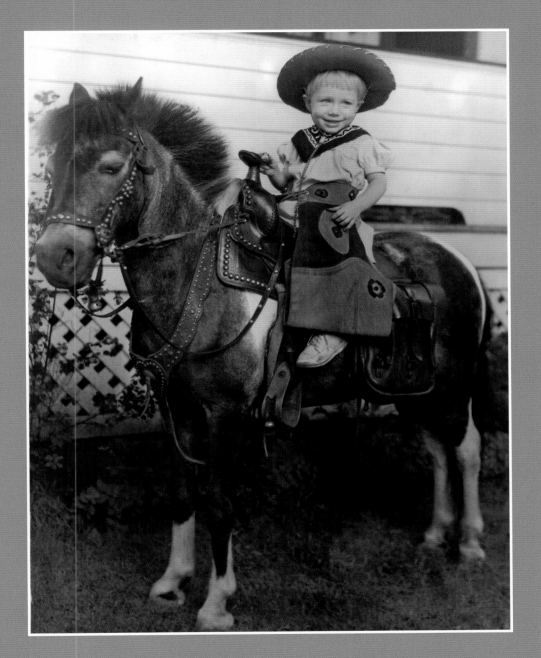

July 1951

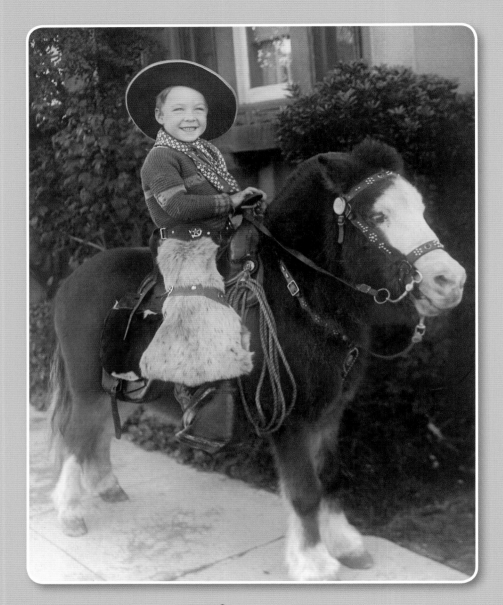

Circa 1940

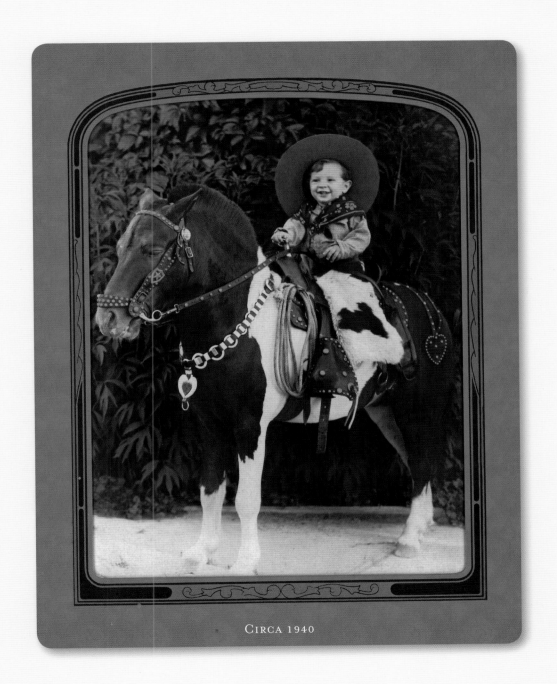

CIRCA 1940

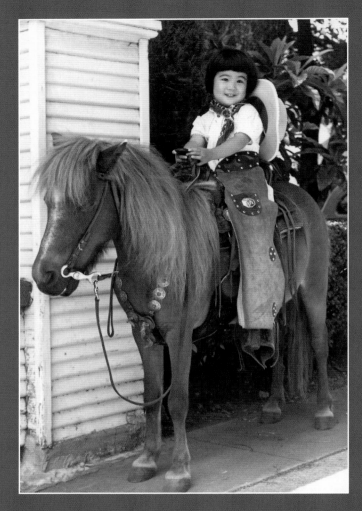

Karen Matsumoto, 3 years and 4 months, Sacramento, California, 1954

Roy Rogers was a veteran of more than 100 films in a career that began in 1938. With his wife Dale Evans, horses Trigger and Buttercup, and brainy German Shepard dog Bullet, he starred in 100 episodes of *The Roy Rogers Show* that ran from 1951 to 1957. Theirs was a show that upheld the family values of the time. Replicas of their flashy fringed and embroidered outfits were favorites with kids everywhere.

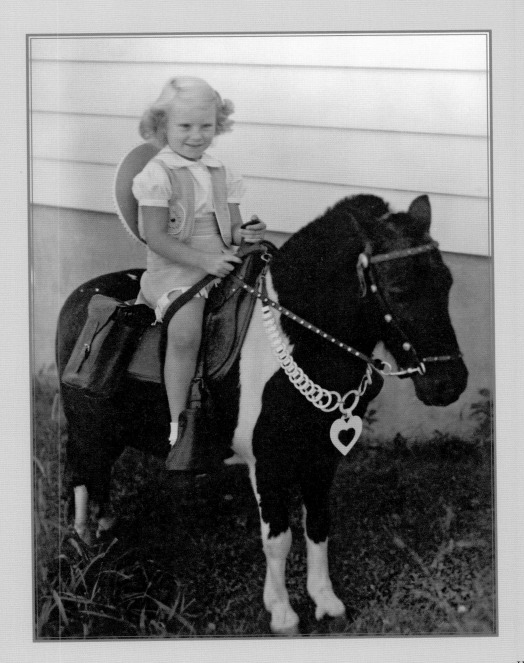

CIRCA 1960

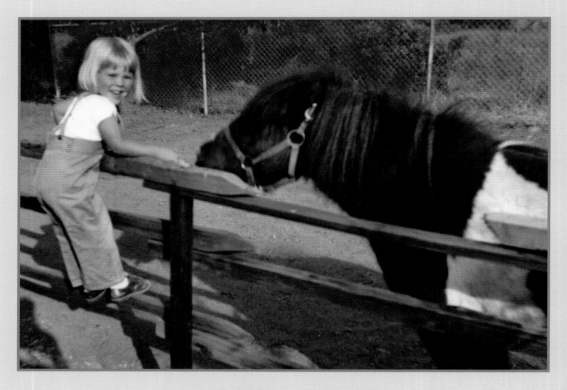

Cathleen, 3 years, 1950

The windswept islands of Chincoteague and Assateague lie just off the coasts of Maryland and Virginia and are home to several hundred wild ponies. Their origins have been the source of much romantic speculation, the most persistent theory being that they are descendents of horses belonging to seventeenth-century colonial settlers. The ponies are rounded up annually and swum across a narrow channel separating the islands from the mainland. They are checked and vaccinated by vets, and a portion of the herd is put up for adoption to keep them and their wild habitat healthy. *(Continued on page 119)*

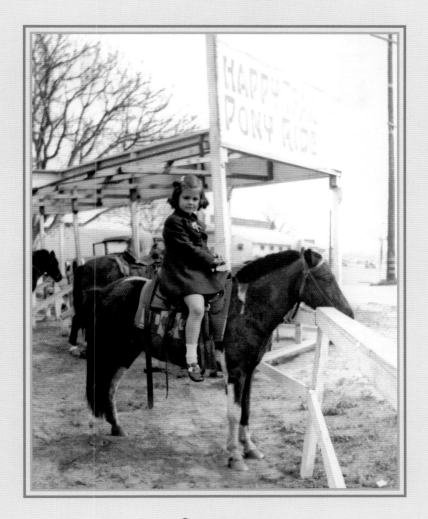

CIRCA 1950

In 1947, Marguerite Henry wrote *Misty of Chincoteague* about a real-life paint filly that was adopted by a local family. The book was an overnight sensation, the real Misty a phenomenon. In 1961 a movie based on the book was released, and by 1962 Misty and her friends were so famous that when a severe storm destroyed most of the forage on the islands, children from every state in the nation sent their saved pennies to buy food for the threatened ponies.

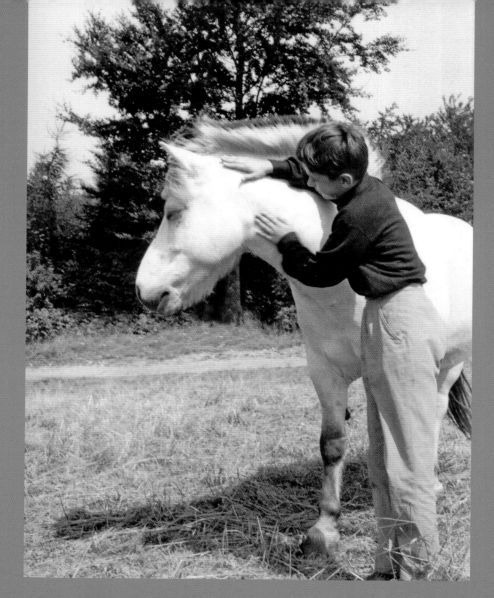

CIRCA 1950

It is important to remember that a pony is a pony, not a small horse. Which is perhaps why we love them so—because they never seem to grow up, and, perhaps, if we love them enough, we won't grow up either.